50 GEMS

Derbyshire

MIKE APPLETON

AMBERLEY

For Emma

First published 2018

Amberley Publishing
The Hill, Stroud
Gloucestershire, GL5 4EP

www.amberley-books.com

Copyright © Mike Appleton, 2018

Map contains Ordnance Survey data © Crown copyright and database right [2018]

The right of Mike Appleton to be identified as the Author
of this work has been asserted in accordance with the
Copyrights, Designs and Patents Act 1988.

British Library Cataloguing in Publication Data.
A catalogue record for this book is available from the British Library.

ISBN 978 1 4456 6726 3 (paperback)
ISBN 978 1 4456 6727 0 (ebook)

Origination by Amberley Publishing.

Printed in Great Britain.

Contents

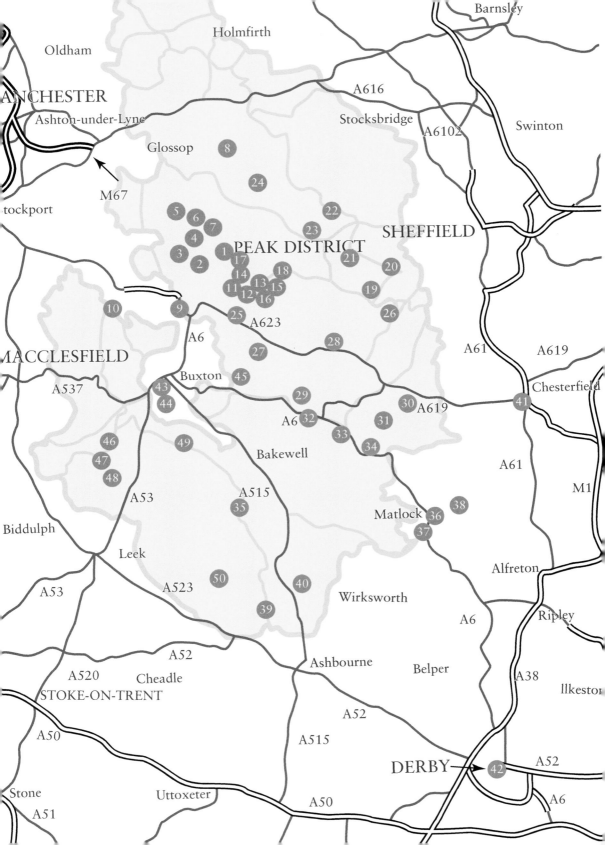

Introduction

'Of the High Peak are seven wonders writ.'

There's a saying, 'If you do what you have always done, then you will get what you always got.' I'm paraphrasing a little, but I'm sure the basic premise remains the same: if you stay with what you know then it is almost impossible to experience new horizons.

Discovering fifty gems of Derbyshire was a simple feat. The Peak District National Park itself, Britain's first, covers 555 square miles. It has two distinct areas: the White Peak in the lower southern part of the park featuring its caves and valleys, and the Dark Peak, which is more northern and wilder. It reaches into five counties – Derbyshire, Cheshire, Staffordshire, Yorkshire and Greater Manchester – and more than 10 million visitors a year enter its boundaries.

Then you mix in those areas just outside the park. Buxton, for instance, is the self-entitled 'Gateway to the Peak', while down in the south-east Derby is one of the finest cities in the country. Choosing gems with such an array on offer was a gift but, of course, I wasn't the first to undertake such a task.

In the fourteenth century, Benedictine monk Ranulphi Higden wrote of Britain as 'a land of many wonders', naming the Peak as the first. William Camden in his *Britannia* (1586) refers to 'Nine things that please us at the Peak we see; a Cave, a Den, a Hole, the Wonder be'. Daniel Defoe described the area as a 'howling wilderness'. While that would now be seen as something to enjoy, back then it was a criticism. Before him, around 100 years previous, poet Michael Drayton named his wonders as Peak Cavern (the Devil's Arse), Poole's Hole, Eldon Hole, St Anne's Well in Buxton, the Ebbing and Flowing Well at Tideswell, Sandy Hill (Mam Tor) and the Peak's medieval hunting forest, 'Peak Forest'. These writers were attempting to emulate, in some way, the Seven Wonders of the World.

Philosopher Thomas Hobbes wrote a poem on the Peak, 'De Mirabilibus Pecci', in 1636. He said, 'Of the High Peak are seven wonders writ. Two fonts, two caves, one Pallace, Mount and Pit.' Like Drayton, he'd referred to seven gems and they were very similar too. The only difference was Chatsworth House replaced Peak Forest. I wonder if Thomas realised he needed to get the gentry on side!

This was then followed by Charles Cotton, who referred to each in his poem 'The Wonders of the Peake' in 1681 – although, his version has been seen as somewhat of a 'skit' due to his humorous descriptions. It seemed to work, though, and as it was widely distributed in the region, touring the Peak became more popular. He'd effectively published a guidebook.

All of our writers' gems are still available to visit too, although the Ebbing and Flowing Well in Tideswell sits in a private house and is no longer a haven for tourists. You also need to be a competent caver to progress into Eldon Hole, but as you'll see in these pages, it is more than worth it.

Thankfully, I wasn't restrained to just seven. I had a little more space to play with than these past venturers and I think my choices will appeal to everyone who wants to come to Derbyshire. They feature idyllic villages, open moors, big caves and quaint churches. We follow old tracks, enjoy sweeping landscapes and seek peace in even the most bustling areas.

Derbyshire has it all and it is an area that deserves to be visited again and again. If you're an outdoors person then it is a necessity. A pilgrimage. In 1932, five 'trespassers' on Kinder Scout were sent to prison for simply going for a walk. We need to remember such sacrifices and remember open access wasn't always thus. Close to 202 square miles of the Peak is now open-access land. You can also walk around the park itself on a new 190-mile route – so much to see and so much to cherish. I hope you enjoy these gems as much as I did.

A Note

For clarity, and ease of visiting, the gems are displayed in four loose sections: North-West, North-East, South-West and South-East. These boundaries are not official and possess a certain amount of artistic licence from the author. Some of the locations of the gems on the map are approximations too; therefore, at the end of each entry you'll see a 'Detail' section describing ways of finding it and, in some cases, an OS grid reference.

The best maps to explore this area are, of course, OS maps – The Peak District: White Peak Area (OL24), The Peak District: Dark Peak Area (OL1). It is also worth looking at Derby (Explorer 259) and Chesterfield and Alfreton (Explorer 269).

North-West

1. Edale

There are several reasons why Edale is the perfect way to start our journey of Derbyshire. Firstly, it is one of the prettiest villages in the county. Secondly, there's plenty to see and do as a visitor. And thirdly, it is the start of the Pennine Way.

For such an iconic place in the minds and hearts of walkers everywhere, do not expect 'bells and whistles' nor homage to one of the most well-known trails in the world. The 267-mile walk is noted by a simple signpost, opposite the Old Nags Head, which is traditionally the start of the route that takes you along the backbone of England to Kirk Yetholm, just inside the Scottish border.

It was inspired by Tom Stephenson, a journalist and champion of walkers' rights, who wrote an article in the *Daily Herald* just three years after the mass trespass in 1932 saw groups of walkers make the journey to Kinder Scout. I have no doubt that Tom would have been moved by such a protest as his article of June 1935 spoke not only of the need for a 'Long Green Trail' – akin to that of the USA's Appalachian and John Muir Trails – but also 'the barring of public access to wild, open moors'. The route would rise 'out of the moor-rimmed bowl of Edale' and head 'northwards to the distant border, through miles of lonely entrancing country'.

A potential trail was first surveyed by the Ramblers' Association, and in 1945 Planning Minister Lewis Silkin met with members of the group to proclaim his support for legalisation that would allow the creation of national parks and protect rights of way – the first step in allowing long-distance routes to become a reality. Plenty of opposition would follow, but on 24 April 1965 Tom finally saw his dream come to fruition. It had taken close to thirty years, but near Malham in the Yorkshire Dales National Park a ribbon was cut, and Tom had his rival to the US.

Edale is an unassuming start for such a piece of rambling heritage, but a good one. Away from the car park near the train station, which is on the picturesque Manchester to Sheffield line, a stroll takes you past the Holy Trinity Parish Church, with mere glimpses of the hills that lie beyond. As well as the Old Nags

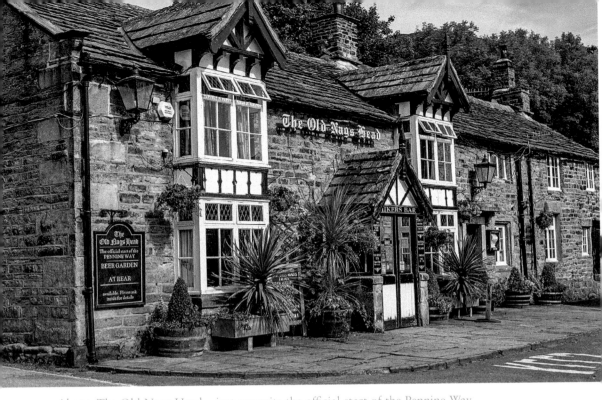

Above: The Old Nags Head – just opposite the official start of the Pennine Way.

Below: Some of the stunning scenery in the first few miles of the trail.

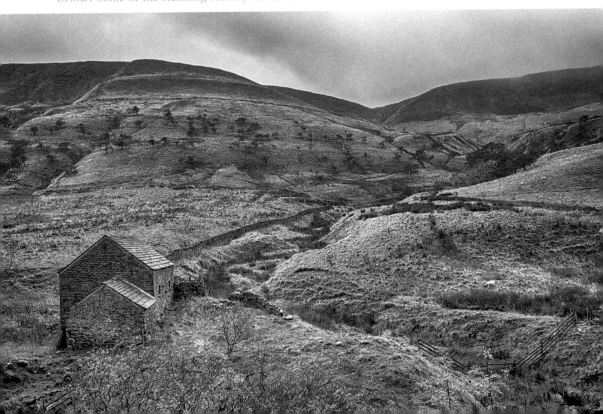

Head (a former smithy built in 1577 and apparently haunted by Second World War airmen) there is the Ramblers Inn near the station, a National Park Centre, a café and local shop.

Edale shares its name with the valley between Mam Tor, Lose Hill and Kinder Scout. Historically, it was the name of the valley surrounding the River Noe and was in the Forest of High Peak with Edale Cross at its centre. It marked the boundary of Campana, Hopedale and Longdendale. Settlements consisted of several booths or cattle farms first founded in the thirteenth century. These became Barber Booth, Upper Booth, Ollerbrook Booth, Nether Booth and the central Grindsbrook Booth, which is effectively the village of Edale today. When the station opened on the Hope Valley Line it was named Edale and thus 'adopted' as the name for all the areas of parish.

Details
Edale is well signposted from Castleton. A good route is to head to Mam Tor and then follow the winding road down to the village. It is also accessible from Hope.

2. Jacob's Ladder

The original Pennine Way would have seen walkers trek north from Edale, straight across Kinder Scout's plateau and onwards to Bleaklow and beyond. But such was its popularity and the resultant erosion, it was rerouted towards Upper Booth and Lee House before arriving at Jacob's Ladder and then returning north.

The new trail effectively followed an old packhorse route that had been used to carry goods across the high Pennine Moors. Salt, cotton and wool would have been exchanged for coal, lead and other goods in what must have been an arduous and exposed trading process for horses and people alike.

At the point where the route crossed the River Noe to climb upwards, local farmer Jacob Marshall created a stepped path in the eighteenth century to make the journey a little easier. Horses couldn't negotiate the steep ascent, so they would go left at the head of the packhorse bridge and then turn a sharp right to arrive at the top of this part of the trail. Marshall then cut a rough route up the hill to the top of the zigzag in order for the tradesmen to arrive before the horses. They would catch a rest while their 'pack' came up the longer path. The farmer also allowed those travellers to stay overnight at Edale Head House, which is now a ruin as you come out of Lee House Farm.

Jacob's Ladder is one of the most popular walks in the Peak and is well worth the direct route to enjoy the views back over Edale village. It can be busy, but on an early morning visit it's possible not to see another soul until you reach Kinder itself.

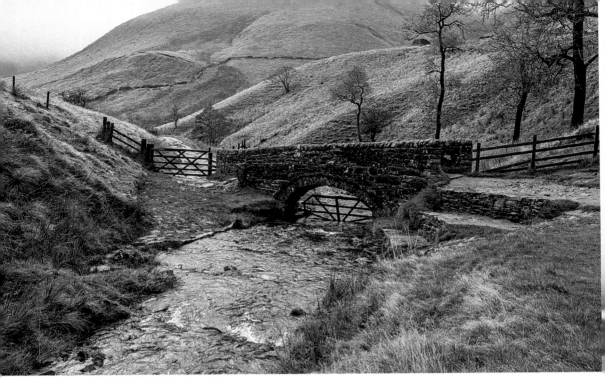

The packhorse bridge is stunning at any angle.

Details
Jacob's Ladder (SK088861) can be visited in two circular walks: either a route taking in Edale to Grindsbrook Clough, Kinder Scout, Kinder Low and back towards the village on the Pennine Way, or the reverse. I went for the latter, walking out of Edale and then proceeding along the Pennine Way through Upper Booth. It is well worth visiting the information shelter on the route at the farm.

3. Edale Cross

My route along the Pennine Way climbs up Jacob's Ladder and then looks to swing north towards Edale Rocks and Kinder Low. But it is worth diverting off the main path for around a quarter of a mile to visit Edale Cross.

Sheltered and inset in a corner where two drystone walls meet, is an interesting medieval wayside and boundary stone. It stands on the parish boundary between Hatfield and Edale, next to the ancient moorland track between those two villages. It is scheduled under the Ancient Monuments and Archaeological Areas Act 1979 because of its national importance. But just how did it end up there?

It is suggested that the cross was thrown down from its original position and found buried in peat by local farmers. They then re-erected it at this site. Initials

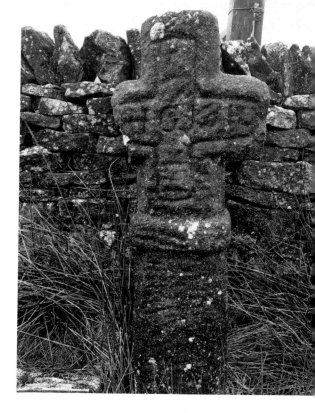

Just a little wander from the Pennine Way, and well worth the diversion.

on the front have the date '1810' alongside them; this could be when the cross was found, or just graffiti.

Historic England says that the Champion Cross, as it is also known, is made from gritstone and the 'cross head is out of proportion with the shaft which suggests that the latter is shorter than it was originally'. It is also clear that the west arm of the cross used to be longer but was damaged. Their website states:

> Both faces of the cross head are decorated with an incised inner cross which contains, on the south side, the inscription HG 1610 and, on the north side, four sets of initials: WD, EH, JH and JS. The end of the east arm of the cross is also inscribed JH and it is assumed that all of these groups of letters are later graffiti while the date and its associated letters may relate to a 17th century survey.

Waymarkers like this were one of several erected during the medieval period, mostly from the ninth to fifteenth centuries. According to one source, this particular one was 'probably erected by the Cistercian monks of Basingwerk Abbey at the southern boundary of land which they received from Henry II in 1157'. Historic England aren't so sure, so I leave it for you to decipher.

Details
Edale Cross is at SK077860, just off the Pennine Way along an obvious path going straight on as the main route turns right, just a third of a mile after Jacob's Ladder. It is just after a gate that allows you to walk to Kinder Low.

4. Kinder Low

You start to understand the size of the Kinder Plateau when you begin to see Edale Rocks. Following the Pennine Way north, these strange shaped geological gems start to impose themselves through the mist … and Kinder is so often covered in mist!

The rocks are gritstone (popular for bouldering) and have a near Gothic quality through the grey skies that so often clog up Kinder.

The summit cairn sits at 633 metres – just 3 metres shy of the official highest point of the 'Scout' plateau, which is at 2,087 feet. Kinder Scout doesn't have a summit marker, so this is close as you're going to get. The views are astounding on a clear day.

Details
The summit cairn, near Kinder Low, is located at SK079870.

It may often be misty, but that doesn't stop you seeing some fantastic geology on the Low.

5. Kinder Downfall

I've been lucky to visit Kinder Downfall, the 98-foot waterfall on Kinder, in two differing states, but largely in the same weather. The first was on a damp and dreary day, where the upper part of the fall near the Pennine Way was flowing decently and the lower part clouded in mist. The second was when I viewed it from lower down in more windy times and saw the fall blow back on itself.

The River Kinder flows over one of the gritstone cliffs and eventually heads into Kinder Reservoir around 1.25 miles away as the crow flies. Around 0.5 miles away is Mermaid's Pool, where legend says an immortal mermaid rises on the eve of Easter to 'reward visitors with the gift of long life ... or to lure down her admirers to their doom'. It is also said that you can see her if you look into the water at sunrise on Easter Sunday.

Details
Kinder Downfall is at SK082889, at the point where the Pennine Way heads west away from Kinder. The Mermaid's Pool is a little more difficult to access, but can be found at SK074886.

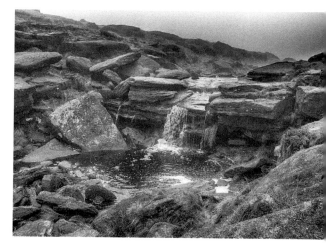

The Downfall on a misty day. This is at the point where it crosses the Pennine Way. Lower down is spectacular.

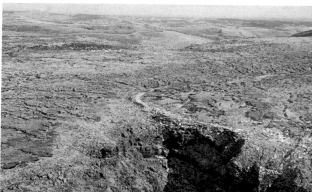

Kinder Downfall from the air. The picture shows the Kinder Plateau before a lot of restoration work was carried out by Moors for the Future. (Image courtesy of Moors for the Future)

6. Kinder Scout

It's hard to think nowadays that people would be sent to prison for simply going on a walk or that as recently as 2000, vast areas of this country were barred from public access.

We take being able to explore the countryside for granted, thanks to the Countryside and Rights of Way (CROW) Act, but even when the Peak District became the country's first national park in 1951, many parts were still inaccessible to the public.

With much of the hills classed as private land, to walk on them meant trespassing, which in turn meant breaking the law. But sometimes people need to challenge the status quo to force change.

One such high-profile event, the Mass Trespass of 1932, was a landmark act of defiance and it has gone down in folklore. While it didn't change policy, it nudged the mindset towards the National Parks and Access to the Countryside Act in 1949, and no doubt the legislation that occurred beyond.

Ironically, the protesters didn't want an open-all-access arrangement, they simply required landowners to create a public path through Kinder Scout, giving them a route to use, free from trespass law, when the land wasn't in use. Kinder was worked around twelve days a year for shooting but was closed at all other times. It is estimated that 15,000 people from Manchester alone went walking every Sunday, but official ramblers' associations were making no progress with access rights. Less than 1 per cent of the Peak was open for walkers, although the more official groups, which contained dukes and earls, could walk on these lands if they applied for permission.

With no end in sight and after being turned away on Bleaklow by local gamekeepers, the Lancashire branch of the British Workers' Sport Federation opted to organise a mass trespass on Kinder Scout. Around 400 walkers set off from Bowden Bridge on Sunday 24 April 1932 and after reaching the plateau, scuffled with the Duke of Devonshire's gamekeepers before continuing their walk. After a short distance they met with a group of trespassers from Sheffield,

This shows the bare peat on Kinder. It is Moors for the Future's control site, showing the impact of no works as compared to work taking place. (Image courtesy of Moors for the Future)

exchanged pleasantries and then returned from where they came. It was a triumphant moment, but worse was to follow.

Five ramblers – Julius ('Jud') Clyne (twenty-three), Arthur Walter ('Tona') Gillett (nineteen), Harry Mendel (twenty-two), David Nussbaum (nineteen) and Bernard ('Benny') Rothman (twenty) – were arrested in Hayfield and joined John Anderson (twenty-one), who was taken into custody at the scuffle itself. The five were charged at New Mills Police Court with 'unlawful assembly and breach of the peace'. Five of the six were found guilty and jailed for between two and six months. Benny was seen as the leader of the trespass and received a three-month sentence for 'riot and inciting riot and assault'. The seed had been sown, though, and a few weeks later more than 10,000 ramblers held an access rally at Winnats Pass.

Local journalists were on board too, no doubt courted by these men before the trespass itself, and some were shocked at the sentences handed down to the ramblers.

It was therefore no surprise that when the National Parks and Access to the Countryside Act was passed, the Peak became its first national park and access at Kinder and Bleaklow was one of the first things to be negotiated. It was a symbolic gesture for what had gone on before. For those that walk on Kinder now it must be strange that this place was once a battleground for access. On most of my visits the mist is down, it's damp and the peat is deep.

But this was a class war, albeit on a minor scale, which eventually meant we could all enjoy the countryside.

Kinder now faces different pressures. It is a very important moorland habitat that needs active management if it is going to survive going forward. Peat is very sensitive to environmental change and is a crucial carbon store.

The Moors for the Future Partnership is tasked with ensuring Kinder Scout and other moorland landscapes are returned to their former glories and viable for future generations. Its work stretches from Nidderdale in the north to Kinder, with seven active projects mainly on Sites of Special Scientific Interest. Those projects cover more than thirty sites.

'Over the past fourteen years the Moors for the Future Partnership has raised funds and implemented conservation works with a value of £28 million,' Chris Dean, Head of Programme Delivery at the Partnership, tells me. He continues:

This has improved the condition of England's most damaged and sensitive moorland habitat.

We have revegetated of 32 square kilometres of bare, eroding and desiccated peat in and around the South Pennine Moors Special Area of Conservation. In line with our mission to restore the quality of the South Pennine Moors and to improve its benefits as a water catchment area, we work towards a diverse ecological, recreational and agricultural resource, which will be managed to ensure its enduring legacy.

The Partnership's first project was in 2003 and from there has grown significantly. The sheer damage and loss of habitat in these precious moorlands meant just

Work on a nearby site, which includes blocking, sphagnum inoculation and plug planting. (Image courtesy of Moors for the Future)

Inset: This sphagnum moss is vital if the plateau and others are to have a future. (Image courtesy of Moors for the Future)

sitting back doing nothing wasn't an option anymore, and by working together significant progress could be achieved. Chris continues:

> Working in partnership enabled us to deliver many benefits for our various partners. The National Trust, a major landowner of Kinder, started regeneration works there and are one of our founding partners. Each partner had different but overlapping priorities, but the restoration of blanket bog was the common solution.
>
> For example, the RSPB's aim is to give nature a home and the National Trust are working towards a healthier natural environment. Natural England helps to protect England's nature and landscapes. Yorkshire Water, United Utilities and Severn Trent recognise the need to keep as much peat on the hills as possible, to prevent it silting up the reservoirs.
>
> Meanwhile, the Environment Agency's priorities include reducing the risk of flooding. Healthy moorlands slow the flow of water from the hills. This contributes to a reduced risk of flooding in surrounding towns and cities during high rainfall events. The EU LIFE programme is funding our work to prevent wildfires on blanket bog. By working in partnership,

we can combine investments and use them on a large, landscape scale to meet a whole range of positive outcomes. We work across large areas with different landowners so that we can join up the dots to achieve results which benefit all our partners and society as a whole.

It's clear the Moors for the Future Partnership has a large remit and a large area to cover. Peatlands cover around 26,000 square kilometres of the UK's land area and the Partnership's work area encompasses some of the most badly degraded parts of that. Walkers on Kinder will see the large white bags crammed full of materials that are used to try and halt erosion.

The Partnership uses stone dams to block the gullies, which are channels formed by the action of wind and rain eroding the peat. These dams raise the water table and trap peat, thus reducing erosion. They also spread chopped cuttings to protect bare peat and these contain heather seeds and fragments of mosses that help to revegetate the moor.

Lime, seed and fertiliser is also spread to kick-start the revegetation process, and that is followed by the planting of sphagnum moss and other moorland species. Some walkers, including this author, have been at the bottom of one of the gullies with peat towering above them. That just isn't sustainable for this environment and would continue without the work of the partnership. Chris says:

On Kinder Scout, the Partnership has completed a number of large projects. We have stabilised and revegetated huge areas of bare peat which would otherwise have continued to erode. We've also built five paths, covering close to 6.5 km. The area is subject to huge pressure from visitors – OS maps around Edale feature amongst the most popular in the country. We aim to create sustainable access along established popular routes. Doing this we increase the area available for ground-nesting birds by narrowing the area of land used by the path.

Another significant and vital aspect of our endeavours is to track the results of our work. Because much of what we do is pioneering new techniques, we have to check that our predictions are correct. We survey moorland plant and animal species to learn over time how effective the work has been. We assess the effects of the work on outcomes such as water quality and flow rate.

We also work with universities and employ a team of scientists to look in detail at the effects of our work on the outcomes that the Partnership is striving towards.

On Kinder, this takes the shape of a moorland laboratory. We've tried out a range of moorland restoration techniques, while leaving a 'control' square with no work done. The difference is astounding. If you look on Google Earth, there is a square on the Northern Edge of Kinder that is black, surrounded by our three trial sites, which are green. The black square is what the whole plateau looked like ten years ago.

The transformation is quite staggering, on both ground level and from above. The Google Earth image Chris refers to can be found here: https://tinyurl.com/MoorsfortheFuture.

It's easy to witness the work being undertaken by visiting Kinder but what benefits does it have? Chris adds:

> The moors of the Peak District and South Pennines contained the most degraded blanket bog in the country. One hundred and fifty years of atmospheric pollution from the industrial powerhouses of Manchester and Sheffield have taken their toll.
>
> Sphagnum moss, the foundation of blanket bog, is delicate and vulnerable to air pollution because it survives by taking in water and nutrients through its porous leaves, instead of having roots. Once this bog-building moss was killed off on a large scale, the moors became drier and much more susceptible to wildfire. This in turn contributed to even more loss of vegetation. This was an environmental catastrophe, because without vegetation cover to protect it, peat is vulnerable to erosion and is quickly lost from the moors.
>
> Most people don't know that blanket bog is rarer than tropical rainforest but stores as much carbon. A healthy blanket bog takes in and stores carbon as peat, which builds up by about one millimetre per year.
>
> Degraded bog with scant vegetation, on the other hand, loses peat as fast as 2.5 centimetres per year. This peat is lost into water systems and the atmosphere, with much of the sediment finding its way into reservoirs.

This results in large costs to the water companies to remove it – with a knock-on effect on everyone's water bill. Once exposed, this peat will re-enter the carbon cycle and contribute to climate change. Furthermore, water falling on desiccated bare peat runs off as fast as it would run off concrete, whereas when it falls onto healthy blanket bog rich in sphagnum, the flow of water is slowed dramatically. This leads to a significant reduction to the risk of flooding downstream.

The moors are an essential home for wildlife. As a priority habitat in the EU's Species and Habitats Directive, it supports nationally and internationally important wildlife, with many of these populations in decline. The Peak District and South Pennines support the only population of mountain hare in England too, while birds such as dunlin, curlew and golden plover rely on the habitat to successfully breed.

Healthy blanket bog is also wetter, so our work results in the chance of wildfire being reduced, putting a halt to the cycle of degradation.

I have to admit, last time I was on Kinder the weather wasn't kind and I got stuck in a bog – three-quarters up my legs – on the way back to Edale. It was only when I extracted myself and the sky eventually cleared that I saw not only its expanse, but the variety of landscape around me. I'd heard stories of what it used to be like, and my experience was no doubt something similar to back then. But mine was localised rather than widespread. Benny and the others trespassed here to gain access to something different, somewhere different from the norm. There were routes elsewhere available to him and the ramblers, but what's the point in doing something you've always done.

Next time you're on Kinder, remember Benny and his cohorts alongside the work of Moors for the Future Partnership and understand you can also be part of it. You can get involved with Moors for the Future's Community Scientists, where you can help monitor moorland species or even get fully trained up to undertake environmental monitoring at specially chosen sites across the Peak District and South Pennines.

Details

There are several routes to Kinder; the previous five gems are effectively one route to the Scout.

Moors for the Future Partnership's chairman, David Chapman, suggests a walk from Edale up Grindsbrook onto Kinder and skirting around the edge of the plateau clockwise. This way you take in Grindslow Knoll, then you move to Kinder Downfall, passing Crowden Tower and the weird and wonderful gritstone rock formations known as the Wool Packs.

A map, compass and map-reading skills are essential on Kinder and a walk there requires previous hill-walking experience.

Thanks to kindertresspass.com for information on the Kinder Trespass. More details on the Moors for the Future Partnership can be found at www.moorsforthefuture.org.uk.

7. Grindsbrook Clough

There are several routes heading off Kinder Scout but the one that heads towards the Wool Packs, Crowden Tower and towards Grindsbrook Clough is a gem. The Wool Packs are eroded stones of all shapes and sizes, while Crowden juts out impressively with views down the valley.

It is the walk to Grindsbrook that impressed me. Firstly, the rock formations are certainly interesting, as is the view back towards Edale. Yet, it was Grindsbrook itself that proved to be a real surprise. After coming off Kinder I came to the head of the Clough feeling unsure whether to descend. The path onwards looked a little unstable and, in all honesty, very steep. I was faced with that or a route towards Hartsthorn and then trying to pick my way down Golden Clough. I sat down for a minute and then got chatting to a couple who had just come the other way. They were both red-faced but smiling from ear to ear and after a brief chat it was clear 'you won't be disappointed' was going to be the right piece of advice.

Grindsbrook is a relatively easy scramble in both directions, but in hindsight probably more fun heading up rather than down. It pays to keep your wits about you, but it's well worth it ... and there's a lovely waterfall midway down.

Following Grindsbrook brings you into a small wood, albeit very briefly, before the well-used path brings you back to the start of the Pennine Way (via a little bit of road) and Edale.

Details
A scramble up Grindsbrook (SK105872) can be reached via Edale by walking past the Old Nags Head (keeping it on your right). It can also be visited, if you want to descend it, by following the gems in order of appearance so far.

Some of the unusual rock features that greet you on the way to Grindsbrook.

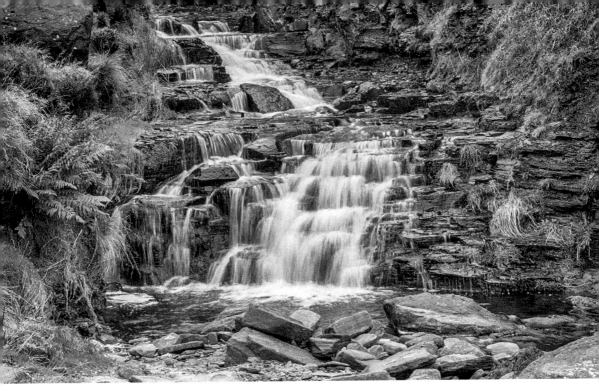

Above: A beautiful waterfall as you head down the 'Clough'.

Below: On the way back to Edale.

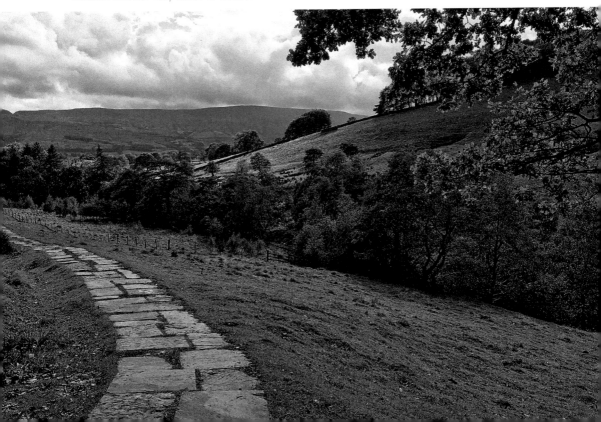

8. Bleaklow

Bleaklow is more than likely not on a visitor's to-do list of Derbyshire, but choose a clear day and the views from Bleaklow Head are well worth the trip. You can see across Lancashire, Cheshire, the Hope Valley and through to Yorkshire as well as enjoying crowd-free paths.

There's also the chance, if you're that way inclined, to visit the wreckage of a USAF Boeing RB-29A Superfortress – and the subsequent memorial – which crashed on the way to Burtonwood in Cheshire on 3 November 1948 at Higher Shelf Stones.

At 2,077 feet, Bleaklow is the second highest point in Derbyshire and effectively has three summits: Bleaklow Head, Bleaklow Stones and Higher Shelf Stones.

Details

Join the Pennine Way as it crosses Snake Pass and trace the route to Bleaklow Head (SK093960). Higher Shelf Stones can be found at SK088947. Taking a map and compass is advisable.

The summit of Bleaklow. (Image courtesy of Phil Tinkler via Shutterstock)

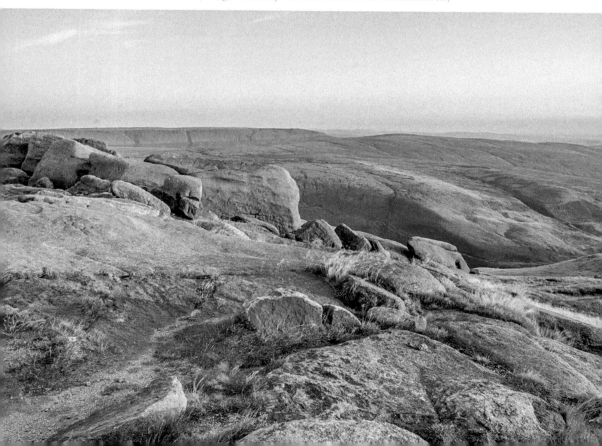

9. Chapel-en-le-Frith

Dubbed the 'Capital of the Peak', although not officially in the Peak District National Park, Chapel-en-le-Frith is a buzzing town with plenty of heritage.

It was established in the twelfth century as a hunting lodge within the Forest of High Peak by the Normans. In 1225, foresters were given permission to build a 'chapel in the forest', hence the name, and the present Church of St Thomas Becket occupies the original site of the chapel. The churchyard also contains a grave said to be of a woodcutter from the days of the forest. It has the letters 'PL' and a depiction of an axe.

In 1648, 1,500 Scottish soldiers were imprisoned at the church during the English Civil War. They were taken prisoner by Cromwell at the Battle of Ribbleton Moor and subsequently locked in for two weeks before being marched to Chester. But after a fortnight, forty-four had died and ten perished on the way to their final destination.

The majority of the church was built a century later, while in its yard is the Eccles Pike Cross, believed to be from Anglo-Saxon times.

The marketplace is still used every Thursday and houses a cross that is much older than the faint seventeenth-century date it depicts. The village stocks are likely to be from the Cromwellian period, while a horse trough and drinking fountain were built to commemorate Queen Victoria's Diamond Jubilee.

The old cross in the marketplace.
It has a date of 1636, but it is older.

Details

Chapel-en-le-Frith is on the A6 towards Buxton and is well signposted. Parking is available in the old town.

10. Taxal

Overlooking the Goyt Valley is Taxal, a small hamlet just on the border of Derbyshire. It was originally in Cheshire, until the county boundaries were altered, and is the epitome of peace and quiet.

It's the Church of St James that is the gem here. Its tower dates from the twelfth century and it has some fascinating memorials. One to William Jaudrell (who died in 1375) and Roger, a soldier who passed away at Agincourt (1415), came from the same family that gave its name to Jodrell Bank, the observatory in Cheshire. There's also a memorial to the 'Yeoman of the Kings Mouth' from 1768, which we can only assume is someone who was a food taster to George II.

The churchyard itself couldn't be a finer resting place for those interned. It also has unique grounds staff to keep everything in trim: a donkey called Mary who looks after it during the summer months – in 2017, she was joined by Henry Albert.

Details

Taxal is off the A5004 near Whaley Bridge and Horwich End – it is easy to miss the turn off.

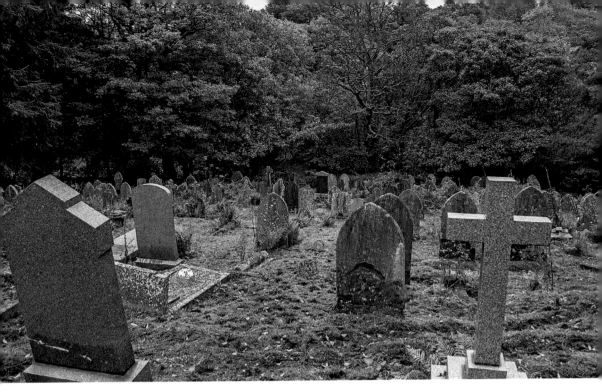

Above: Sadly, no sign of the donkey.

Below: Church of St James.

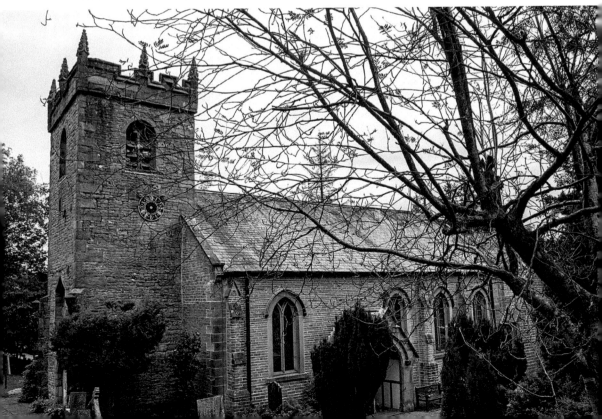

North-East

11. Winnats Pass

Of all the entrances to Castleton and the Hope Valley, there couldn't be a more dramatic one than that of Winnats Pass. From the rolling dales of Derbyshire, with Mam Tor on your left, to being enveloped suddenly on both sides by rising limestone and grass cliffs as you make a steep descent, there is no place like it in the Peak.

There are two trains of thought to how Winnats, which derives its name from 'Windy Gates', came to be such a stunning gem. The first is a simple one: it's a collapsed cave system. The valley was once under a tropical sea and the resultant limestone is packed with fossils of sea creatures. Glaciation saw water find its way into various cracks and fissures and from there a cave system formed and eventually collapsed. This geology is found throughout the area and in Speedwell Cavern.

The other theory is that it was a ravine. The caves that exist throughout the Pass were here long before Winnats itself and this narrow, steep-sided ravine was formed by water erosion. Indeed, having spoken to local cavers it seems that on one side of Winnats there are certain rock and geological features that aren't found on the other. This would suggest that both sides almost formed independently and were then separated by some means. Both theories have their place and seem equally as likely, but even the geologists and experts aren't sure.

Winnats is certainly a fascinating place and has been for generations. Historically, mine shafts were sunk all over it with the extraction of lead prevalent during the eighteenth century. It was during the search for this metal that Blue John was found and then mined for ornaments and jewellery. This still continues on a smaller scale at Blue John Cavern and also at Treak Cliff Cavern, which we will visit later in this book.

Winnats is also a Site of Special Scientific Interest, with Jacob's Ladder and Derby Hawkweed finding the conditions perfect to flourish despite them being

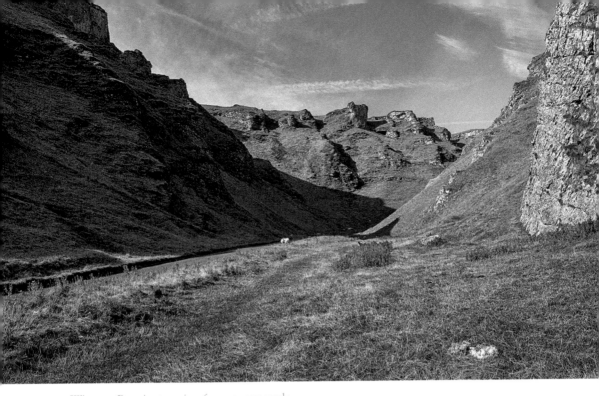

Winnats Pass is stunning from every angle.

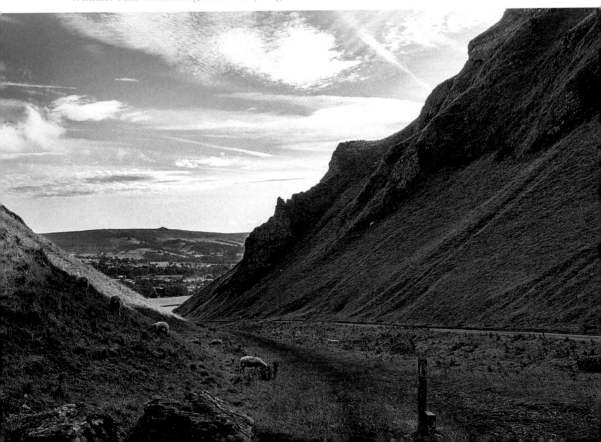

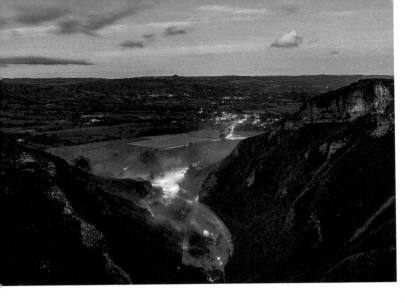

The Waterlicht event. (Image courtesy of Mark Tierney, www. tierneyphotography. co.uk)

some of the rarest in the world. The latter was first discovered at Winnats in 1966 and has never been recorded anywhere else in Britain. It is classed as 'Critically Endangered', while Jacob's is only prevalent in cool climates at altitude.

Returning to the 'windy gates', unless you are at the Pass very early in the morning or late at night it is rare you will get it to yourself. As for wind, the only sounds you are likely to hear are cars going over the cattle grid near the entrance to Speedwell Cavern. A lot of traffic comes down here but that wasn't always the case. Sadly, the permanent closure of the A625 in 1979 due to a landslip means it is very busy indeed.

The Pass was also the scene of a very grisly murder in 1758 involving a couple called Alan and Clara. They had intended to elope at Peak Forest Chapel after Alan was threatened by Clara's family because he was from a poorer class. They stopped at Stoney Middleton and then Castleton on their way but never made it to the chapel, coming across some drunken miners instead. The lead workers thought the couple were rich and plotted to steal from them.

Apparently, they pulled the couple from their horses as they rode through the Pass, stole their money and then murdered them. Their bodies were thrown down a mine shaft and only discovered a decade later.

Winnats had its own ideas in terms of retribution and all the wrongdoers died in tragic circumstances afterwards. According to the National Trust:

> One is said to have fallen from a cliff near the place of the murder and another was hit by a falling stone there, one committed suicide, one went mad, and the last was so guilt-ridden that he confessed it all and the names of his accomplices on his deathbed twenty years later. It is rumoured that he used his share of the stolen money to buy horses, which suffered from ill health so turned out to be bad investments, leaving him in poverty over his final days.

Alan and Clara are buried in Castleton and the red leather saddle on display at Speedwell is said to have belonged to her.

Waterlicht
by Daan
Roosegaarde in
Winnats Pass
during Abandon
Normal Devices
Festival 2017.
(Image courtesy
of Chris Foster)

In 2017, the whole of Winnats was lit up by Waterlicht – an 'ambitious and large-scale digital installation by Dutch designer Daan Roosegaarde with International Design and Innovation Studio Roosegaarde'. It was part of the Abandon Normal Devices Festival and set out to 'virtually flood Winnats Pass with light and smoke to reveal the geological formations of the site and its history'.

Details
Winnats Pass is a dramatic entrance (or exit) to (or from!) Castleton.

12. Speedwell Cavern

Show caves always have their own unique features that set each apart from their neighbours. Whether it is a natural formation, a legend or a secret past, there's a gem in each cavern that makes a visit special and memorable. At Speedwell Cavern, an eighteenth-century mine, it is the journey that makes it very special indeed.

For cavers, the multitude of passages that head towards Peak Cavern and Titan (a 141.5-metre shaft that was discovered in 1999, although not made available to the public for several years after) make it a draw for miles around. There are around 11 miles of passages that connect to the nearby Peak Cavern and they include a multitude of mine workings, sumps and secret passages to keep subterranean fans busy for years. More are being discovered every year.

But that doesn't mean that the mere mortal should miss out. After heading through the rather unassuming entrance and picking your way down 105 steps, you find yourself ushered onto a boat. Your guide then takes you along an underground canal, in relative peace and quiet, to get a glimpse of what it must have been like for miners making this journey more than 200 years ago.

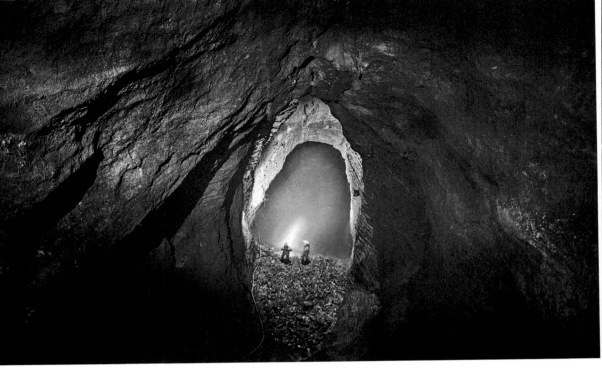

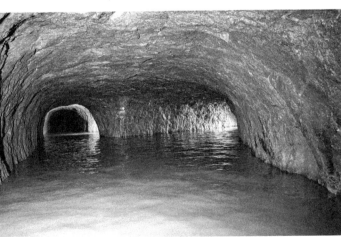

Speedwell began life as Oakden's Level before becoming widely known as Navigation Mine because of the boat that transported lead ore to the surface. The passage is flooded now and kept at a depth of around 3 feet, but even without the water it's pretty clear to see the constricted conditions lead would have been extracted at. Several passages intersect the canal at various points along the journey, but at around halfway you reach the Longcliffe Vein and the Half Way House where boats can cross.

At the end of the canal you enter the limestone cavern itself. Visitors can see the wonderful formations and the fantastic Bottomless Pit – a huge subterranean lake. Miners found this by breaking into the chamber at mid-height as they constructed the canal. It is thought this lake would have been around 150 metres

deep at one point, but as it was filled with spoil it lost much of its depth. However, it got its name because when debris was thrown in, its level never seemed to rise. The miners wouldn't have seen the water overflowing into smaller passages, eventually resurging at Russet Well and Slop Moll in Castleton. It also floods during periods of bad weather.

Make sure you check out the shop on your return to the surface as it has a small alcove packed with artefacts.

Details

Speedwell Cavern is in Castleton, near Winnats Pass. You can park on site and there is also parking a short walk away, which is free during the week.

Opening times can be found at www.speedwellcavern.co.uk. There are a number of options for tickets, which also can be found at the website – with joint tickets for Speedwell and Peak Cavern, it is well worth the value.

13. Peak Cavern

While Speedwell Cavern could be considered an obscured gem in how you are welcomed into its inner reaches, there's certainly no hiding the entrance to Peak Cavern. At 60 feet high, 102 feet wide and 340 feet long it is the largest in Britain. Imposing and dramatic, people made rope in its confines until the early stages of the last century, while legend says it was a hiding place for bandits. Its real name is the Devil's Arse ... but more on that later!

While it doesn't have the most flattering name ever, Peak Cavern is a place well worth a visit whatever the season. Tours operate frequently and there's a rope-making demonstration thrown in as well. At Christmas time, the acoustics of the cavern come to the fore as concerts are held within that entrance. It is a multifunctioning cave that gives visitors plenty of sensory experiences.

Beyond the show cave lies one of the most extensive cave systems in the country. Peak and Speedwell are intricately linked not only geologically and hydrologically by multitude of passages (getting close to 11 miles with more being discovered all the time) but by a significant family connection too.

John Harrison is the director of Speedwell Cavern and his remit also involves the operation of Peak Cavern. His grandfather, Freddy, bought Speedwell in 1939 but sadly died young. That cavern then transferred to his sons and, through time, to John. He said,

I came back to the business in 1989 after the death of my uncle and have been here ever since. I guided at Speedwell from the age of around thirteen or fourteen. I left to go to university and didn't come back for around

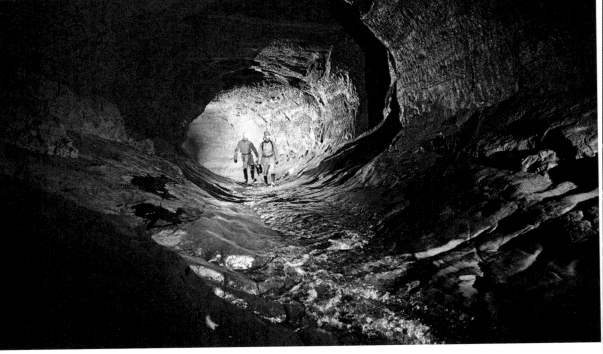

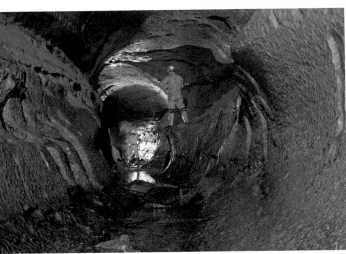

Trips to the upstream and downstream sumps are not to be missed. (Images courtesy of John Harrison/Speedwell)

twelve years but when I did it seemed natural to come back here. We took over the operation of Peak Cavern around nine years later.

The cavern is on Crown estate – the Duchy of Lancaster – and was always historically run via a custodian appointed by the duchy. When the last custodian retired they decided to put it up for lease. Sensing an opportunity, my brother-in-law Jeremy Gosling and I put a plan together to become tenants and we were successful. We took over on Good Friday in 1998 – only a week after we'd been told we were successful. We managed to find three members of staff who had worked here in prior seasons and opened it with three guides.

It's fair to say we didn't know how it would work out but that first season gave us a little knowledge on what we could and couldn't do.

In the winter we drew up some plans for a proper entrance and kiosk, reintroduced rope-making as part of the tour and built it up to what it is today.

Anyone who has been on the trip will surely admit John and Jeremy have it spot on. It is at just the right length and the rope-making demonstration is an excellent addition.

Not many visitors will know that the tour used to go a little further too. Before 1975, as now, visitors could see the impressive Great Cave, Roger Rains House and Pluto's Dining Room – all accessible through the Vestibule and Lumbago Walk (you'll understand why it gets that name when you stretch your back out afterwards). But back then, once punters reached the Devil's Staircase, they could descend to the Halfway House and Five Arches to the junction of the Buxton and Speedwell Water passages. John continues:

The section beyond the Staircase can flood, on average, around two or three times a year. When it does the volume of water backs up and carries a lot of silt. When that part of the cave was open, and a flood occurred, the Staircase needed to be cleaned and that took a lot of time. You could also have to do it again because of subsequent flooding.

Later, the BBC were filming the *Chronicles of Narnia* here and wanted to use the section down the original steps. They put in a camera track and as part of the deal dug up the existing steps to make it look more natural. Then, as radon was being discovered in caves, the custodian had to look at the best way of minimising its impact on guides.

Therefore, with everything in place – the flooding, loss of steps and radon – it made sense for them to stop the tour at the gates just above the Staircase.

When Jeremy and I came in we initially planned to reopen that section because it is beautiful. But after the first summer we felt it was more important to make the rope demonstrations a priority as they are an important part of the cavern's heritage. Reopening that passage would have made the tour a lot longer and experience told us it was already at the right timescale for the vast majority of our customers.

We have worked with the Technical Speleological Group (TSG), a local caving club, to gradually de-show cave that section and bring it back to a natural state. We have also worked with them to create an access system for cavers that works for us all as at Speedwell and Peak there are a number of entrances to the system. All we ask is that cavers sign an indemnity form once a season.

And the concerts?

They are really popular! Originally, local cavers ran a carol concert for the benefit of local charities. It became really popular, but the police put a

The Mucky Ducks. (Image courtesy of Renuka Russell)

stop to it because they couldn't cope with parking and access in the village. Obviously, the market was there so we gave it a go. We originally built a stage above the Swine Hole [a passage in the entrance] and put on a brass band and barbershop choir. Eventually, we learnt the band was best and did away with the stage. Now we sell out, and the acoustics are superb.

Thanks to John and that relationship with the TSG, I had the opportunity to venture beyond the confines of the show cave with members Phil Wolstenholme, Ann Soulsby and Alan Brentnall. We met at the chapel, the club's headquarters in Castleton, donned our caving equipment and then walked up to the Devil's Arse.

The cave was originally known by *that* name until around 1880. It was changed to 'Peak Cavern' in order not to cause offence to Queen Victoria, who was making a visit. That historic name is more widely used now as common sensibilities are probably not as rigid as they were back then. Peak Cavern embraces its name, and why shouldn't it?

Apparently, the cave came by that name because of the strange gurgling sounds found within as flood water drained away ... and I would certainly vouch for those sounds when I visited! After passing through the show cave, which in itself is a great trip with plenty to see, you arrive at the gate and the camera track installed by the BBC.

Phil had been a superb guide already, a real ardent caver with a passion for mining that shines in his book entitled *The Castleton Mines: A Descriptive and Visual History*. We took the option to try out the slide for ourselves; Ann flew

down, followed by Phil and myself, quickly picking up speed before coming to a halt at the bottom. I was pleased I took that route and not tried to stumble down what is left of the Devil's Staircase as there was no way I would have stayed upright. I found that out on the way back.

The cave continues through to the Halfway House and Five Arches before a right turn to follow Speedwell Water. Victoria Aven follows – a staggering sight at some 250 feet high – before the Mucky Ducks (as horrible as they sound). These are crawling sections of passage with limited airspace alongside gloopy, sucking sounds (the Devil's Arse in full aural ability!). The passage then begins to constrict in the way of a narrow trench before arriving at Surprise View – a 20 foot climb down on a fixed ladder.

We're not halfway into the trip at this point and just off the main route you can see passages and squeezes heading off in all directions. We're only in the Upper Gallery and already its size is impressive. Over the years Peak has been the scene of many digs and explorations; for instance, Pickering's Passage (before Surprise View) arrives at Moss Chamber, which is named in commemoration of twenty-year-old Neil Moss who died in Peak in March 1959. Courageous attempts to rescue him failed after he got trapped in an unexplored narrow shaft. His body is still in place in this capped fissure to this day. Then you have the Treasury close by and also White River Series with its stunning formations – and I'm only scratching the surface.

Back on our route: at the bottom of the ladder we turned right and headed downstream for more than 1,000 feet towards Buxton Water Sump – some of the finest caving I have experienced. Then, once retracing our steps, we moved upstream to visit Far Sump. The passage on this trip was impressive, with several digs in evidence and a number of boulder piles before we reached the sump.

All that was then left for us to do was to head back to Surprise View and make our way back to the surface. I took my time on the way back, allowing Phil and Ann to discuss TSG plans and prod and poke into various holes while I tried to just absorb the enormity of the cave ... and get my breath back. Even within the first few metres of the return I found myself marvelling at the size of the boulders I was about to climb under and the aven above. I wanted to enjoy every step and I certainly did.

Scrambling back through the Ducks and then up the Staircase, we came out into the show cave and a party of around ten visitors. The guide made a comment that we looked like we'd had a good time and that her group should move back to allow us to pass. She was right, it had been an unforgettable experience.

Details

Peak Cavern is in Castleton with venue-specific parking available. It is open daily from 10 a.m. to 5 p.m. from April to October, with the last tour beginning at 4 p.m. From November to March it opens 10 a.m. to 5 p.m. at weekends and is open daily during school holidays. Outside those days, two tours a day operate at 11 a.m. and 2 p.m.

Prices can be found by logging on to www.peakcavern.co.uk.

14. Treak Cliff Cavern

'I only came here for a few weeks, but in February 2018 I clocked up my twentieth year!'

With such beauty within it's easy to see why Gary Ridley, director at Treak Cliff Cavern, has stayed as long as he has.

Treak Cliff Cavern is unique not only in the way you enter the mine – through a TARDIS door – but also in its scale and, dare I say it, realism. This is a working mine; Gary mines Blue John, which is on sale in the cavern's shop.

Treak Cliff also has two distinctive themes: the mine itself and the stunning limestone cavern a little further in.

You begin your tour by walking through the long tunnel, created by miners in the early 1700s. The exact date of construction isn't clear but recent research revealed that mining was taking place at Treak Cliff near to the current cavern's entrance before 1699. Evidence of Blue John mining was also reported in 1709, at an unknown location.

It took them two and a half years to dig out the tunnel by hand – hard labour, with the hope of finding significant amounts of lead inside keeping them going. But after all that work, there wasn't enough lead to satisfy their investment until they happened across a blue stone that was banded in colour. Wanting to at least make some kind of return they decided to extract it and see if it had any value … and by luck rather than

Blue John.

judgement it did. It proved to be very popular with early industrialists and nobility for use in their houses as well as for jewellery and ornamental use.

Blue John is unique to Treak Cliff and the nearby Blue John Cavern. It is formed when the exact geological and environmental conditions are just right. It needs the perfect mix of limestone, radioactive elements and fluorine ions alongside a special set of circumstances and pressures to have a chance. As you will see on the tour, it's the colour that makes it so sought after and it can only be legally extracted from these two sites. Of course, that hasn't stopped people in the past trying all sorts of ways to acquire it around Winnats Pass. Gary told me that one morning he had found Blue John buried just under the surface at Treak Cliff after it had been illegally dug out overnight. There was also a well-known mine on Winnats where the stone was prevalent, until extraction was made illegal. These are special sites, SSSIs, and mining has to take place under strict regulations.

Upon entering the cavern it isn't long before you see Blue John in existence, and Gary explained how he found it:

When I started here I'd just been made redundant as a miner at Stoney Middleton. Initially, I wanted to be a National Trust warden but getting into that line of work is difficult so I came to Treak Cliff instead. Back then it was stuck in the past. The family had a shop in the village and all the money that came from the cavern went down there. As a result, the place had become very run down.

I liked to do odd jobs, so I ended up doing things around the place like putting a water system into the toilets. It grew from there and after a while they made me manager and now I am a director. Vicky Turner is the owner and since she took full ownership we have invested back in the cavern.

I mine Blue John here and in 2015 we discovered another vein. Originally, to get the stone out, we would drill holes in the limestone, fill them with wooden pegs and split them with chisels to break lumps out. This is called 'plug and feather' but it can be damaging to the stone as well as being very noisy too. So, we tried out a new method using a particular type of chainsaw. We wouldn't have dug in this area – so close to the entrance and tourist

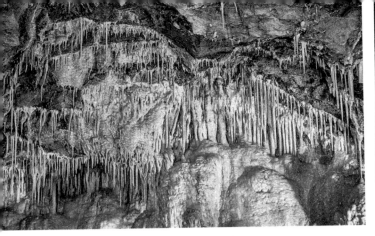

Stunning features lie further into the cavern.

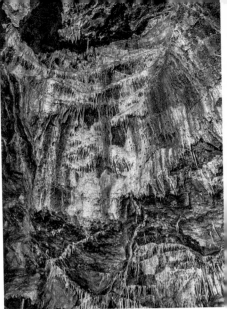

route – but as it was close to a plug socket it made sense to give it a try. We started cutting into limestone and found Blue John, and there was a lot of it!

We sent off a sample to Dr Trevor Ford OBE, who is an expert on Blue John, and he confirmed it was another vein – the first new one for around 150 years! There are fourteen known veins in the hill as a whole, so this is the fifteenth.

It's a beautiful stone and in total we only take out around half a ton a year. That is plenty for us. It takes a long time to process and we couldn't store any more. It has to be dried out and treated with resins before it can be used. And until you get it outside, you don't really know what you have got.

Incidentally, this vein was the second major find in the cavern in a spell of around two years. In January 2013, the 'Lost Vein' was rediscovered. It had been hidden for more than seventy years after its original finder, John Royse, died before he could reveal the exact location to its new mine owner the then nineteen-year-old Peter Harrison – the same family that owned Speedwell.

Royse had actually helped convert the mine into a show cave in 1935, so we have him to thank for this superb trip. It was found seventy years later by Peter's grandson John Turner and Gary, hidden under an old carpet and covered in clay. Apparently, Royse was known to hide his work in this way.

For someone who has discovered his own vein, Gary is a fairly humble man. He didn't even tell me its name – the Ridley Vein. He talks in a soft, authoritative tone and I'd imagine that every tour he takes is just like his first.

Moving further inside visitors can see fossils, calcite crystals, stunning Blue John deposits and where Gary mines. It's an interesting trip packed full of historic information and facts. It's popular with school trips too, but there's enough here to keep everyone happy. Bowls, jewellery and other ornaments are made on site. I had the privilege of seeing the workshop in action and those wares are on sale in the shop.

After spending some time talking about the mining of Blue John and the Lost Vein discovery we moved into the younger part of the cave, which was discovered in 1926 as miners looked for different veins. It's a visual juxtaposition from the mining area, but equally as fulfilling for visitors.

Formations are all around and it has the best display of stalactites and flowstone at the back end that I have ever seen in a show cave. I have no doubt there are further discoveries to be found too.

Treak Cliff is different from other show caves because of its nature. It's a working environment and one steeped in history too. Not to be missed!

Details

Treak Cliff Cavern is on Buxton Road in Castleton. If approaching from Castleton village, the best way to visit is by not veering off the road at the obvious point to go through Winnats Pass. Stay to the right and it is around 0.25 miles on your left.

Entry is by guided tour only and if visiting in winter its worth calling in advance to ensure your tour can go ahead. For price details visit www.bluejohnstone.com.

15. Castleton

On the outside, Castleton is a busy village with several shops that specialise in Blue John. It also houses several tea rooms and pubs to keep visitors happy. But away from this façade is a whole lot more if you're prepared to wander off the beaten track.

Castleton was first mentioned as 'Pechesers' in the Domesday Book (1086) and its layout has the traditional grid pattern of medieval streets. Near the Peak District National Park's car park there are remnants of a ditch that once surrounded the village, built as part of the town's defences.

Although the church, dedicated to St Edmunds, was restored in around 1837, it has features that are a lot older including a thirteenth-century tracery. Records also show it was erected in time of Edward the Confessor. That historical flavour continues at Peveril Castle, a short walk away from the centre of the village. It is one of England's earliest Norman fortresses and was completed in 1086 for William Peverel, a favoured knight of William the Conqueror.

Then you have mining and the caverns. The village's prosperity came from lead mining. Odin Mine was one of the oldest in the country and is now owned by the National Trust, with its spoil heaps protected archaeological sites. Peak, Speedwell, Treak Cliff and Blue John Caverns are all open to the public and a short walk will take you to Cavedale, an ancient collapsed cave and former

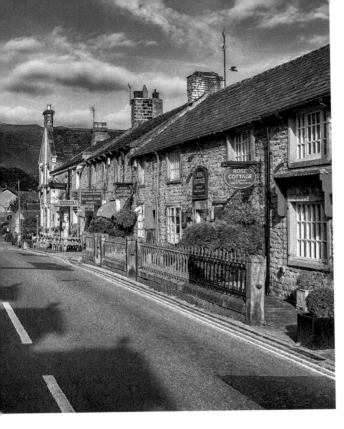

Castleton is a busy little village with plenty to see and do.

packhorse route to the west and Cheshire salt mines. Added to that is the proximity of Mam Tor and the wonderful Great Ridge walk.

If you're interested in local folklore then some of Castleton's sights are supposedly haunted. You will already have read about Alan and Clara at Winnats but at the Castle Hotel there's apparently a 'jilted bride in room four, a nurse and legless soldier in the cellar, a small elderly woman in grey, a middle-aged man in a pinstriped suit in rooms seven and ten; and a legless woman travelling corridors waist deep in the floorboards,' according to the Peak Experience Guides. This pub was a stop-off point for the Wellington Express Coach, which linked Manchester and Sheffield as far back as the 1800s.

'At Peveril Castle some have heard a long-dead knight and the song of a medieval lady. An unlucky prisoner was starved for six days before his hand was cut off, in 1403,' the leaflet goes on to add. We'll leave that for you to find out.

One particular custom that is still observed on an annual basis is Castleton Garland Day, which coincides with Oak Apple Day. It is said to be in honour of the Restoration of Charles II in 1660. It's a colourful ceremony held every year around the end of May. It sees the Garland King leading a procession through Castleton on horseback. The king, usually a local elected by committee, is covered to the waist in a bell-shaped floral garland. That is 'meant to represent the oak tree in which he (King Charles) hid after the Battle of Worcester. Some folklorists suspect that it is actually a much older custom that transferred from May Day as many May celebrations did after having been banned by the Puritans. The Garland King certainly resembles a kind of Jack in the Green,' according to www.castleton-garland.com.

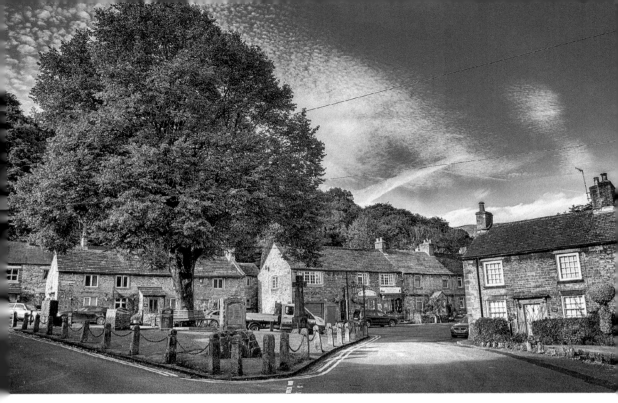

The old marketplace – one of the quieter places to reflect.

Frank Garland writes a superb description of the custom, which is likely to transcend back to the reign of William IV and the 1830s. He writes that the village's woodwind band used to provide the music whereas now it is a brass band.

'Otherwise not much had changed,' he adds, 'apart from the dancing and the king's costume, which only gets revealed when the beehive shaped garland, which he wears over his head as he rides through the village, is hoisted to the top of the church tower.'

The parade would stop outside each pub in the village, with the organisers (who were Castleton's bell-ringers) dancing, but that changed in 1897 with Queen Victoria's Jubilee. Children became more prominent in the celebration and that is something that is still carried on today. Incidentally, there is a tree in the centre of Castleton planted at the time to celebrate the jubilee.

Also, consorts aren't jesters to the king now, they are local ladies after 'the old consort retired and … the chairman of the Garland Committee persuaded his daughter to take on the role'. In the past this has included Vicky Turner from Treak Cliff Cavern.

Details
Castleton is at the end of the A6187, as if approaching from Hope. A better way in is via Winnats Pass, which goes through Perryfoot or following the road alongside Rushup Edge from Chapel-en-le-Frith. The best place to park is at the Peak District National Park car park.

16. Peveril Castle

If there was ever a place to construct a castle, then the best site would surely be on an almost inaccessible clifftop. It would afford great views of all around it and be located among an impenetrable landscape for any would-be attackers. It would also let those below know who was there and who was in charge.

Peveril Castle scores highly on all these requirements. It's an imposing presence in Castleton – set above the rooftops and always in view, yet seemingly so far away.

Walking up from the centre of the village, with St Edmunds Church on your left, it isn't long before you find yourself at the entrance to the castle; however, the actual remains are in the distance up the hillside.

Peveril Castle is one of England's earliest Norman fortresses and was built by William Peveril (his surname is also referred to as Peverel) and referenced as such in the Domesday Book. Therefore, construction could be said to have been before 1086 or at least after the Norman Conquest of 1066. Peveril was a favourite of William the Conqueror and was bestowed a number of manors after the Conquest. Castleton was likely one of them and he fortified the site as well as building a wooden keep. It seems these buildings were always intended to be stone, rather than wood, and they were later rebuilt in 1176 by Henry II who confiscated the Peveril estates seemingly because William's son wouldn't toe the line. The castle fell into disrepair after the Tudor period (1485–1603) and by the seventeenth century was only used as a courthouse.

Nowadays, the ruins are well preserved and managed by English Heritage. After making the effort to walk up to the castle – and it is an effort – you get a flavour of what the original site would have been like and how imposing it was to all that saw it. The views are stunning. The walk up to the castle is steep, for obvious reasons, and the original way into it would have been along the ridge, which is above Cavedale.

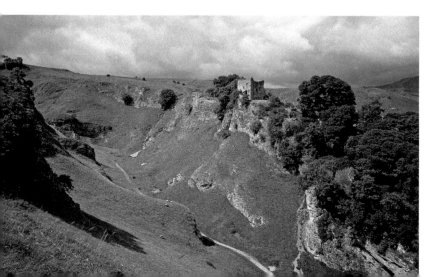

From the south-east, looking across Cavedale towards the castle. (Image courtesy of Historic England Archive)

Details

The best way to visit the castle is to park in at the Peak District National car park and walk up to it following the brown signs. Keep the church to your left and you can't miss it.

Opening times vary on the time of year you are visiting and it is worth noting there is a ten- to fifteen-minute uphill walk to the castle from the visitor centre. Prices are from £5.60 for adults, £5 for concessions and £3.40 for children up to the age of fifteen.

17. Mam Tor

Dominating the skyline to the west of Castleton is the 'shivering mountain' Mam Tor. It stands at 1,696 feet and is part of the Great Ridge, which takes in Hollins Cross, Back Tor and Lose Hill – one of the finest walks in the Peak.

At approximately 320 million years old, geologically it is made up of layered black shales and sandstone and located on the southern edge of the Dark Peak, overlooking the White Peak.

Its name means 'mother hill' because of the landslips on its eastern side that have shaped a number of mini hills. Its unstable nature is further enhanced by the fact the original A625, which connected Chapel-en-le-Frith to Sheffield, was permanently closed because the 'shivering mountain' lived up to its name and shed it.

The peak's summit (easily assessable on a fairly short walk) was also the site of a late Bronze Age and early Iron Age univallate hill fort. Now a scheduled monument, it includes two Bronze Age burial mounds, which can be found below the summit and on it.

According to Historic England, in its official description of the monument:

Substantial areas are intact and include the south entrance and the main occupation areas. The use of the tor as a focus for prehistoric burials, illustrated by the two bowl barrows at the south end of the monument, demonstrates that human activity on the Tor was of considerable antiquity by the time the hill fort was constructed. Bowl barrows are funerary monuments dating from the Late Neolithic to the Late Bronze Age (c. 2400–1500 BC) and were constructed as hemispherical mounds of rubble or earth covering single or multiple burials.

Apparently one of these barrows was used as a Second World War searchlight emplacement too.

The hill fort comprised of a 'tongue-shaped area of around six hectares enclosed by a single line of defensive earthworks including a rampart, berm,

ditch and counterscarp bank'. On either side of the ridge, the remains of hut platforms also exist and 'can be seen cut into the west and east-facing slope'.

The rampart itself was box-like and created from 'successive layers of various materials including soil, clay mixed with stones, and rubble'.

Archaeological digs also found 'whetstones, fragments of shale bracelets, and large quantities of pot sherds', which indicated a 'single phase of occupation during the early first millennium BC which was confirmed by radiocarbon dating of charcoal from two of the huts'.

Other finds included flint tools and a 'Neolithic polished stone axe, indicative of possible settlement in the third millennium BC, prior to the construction of the hill fort'. They also found a fragment of a socketed bronze axe that was dated to around 600 BC, indicating 'the possible use of the hill fort in the final phase of the Bronze Age, 500 years after the other excavated huts were inhabited'.

A fascinating place and a must visit if you're in the Peak. Up on the hill on a clear day it's clear why it was a perfect place for a fort. It is well protected by Mam Tor's slopes and it's easy to see anyone that may be approaching with ulterior motives. Parts of these remains can be seen today in the earth but it's pretty obvious that most visitors will be approaching on the path from the National Trust car park with the sole intention of taking the Great Ridge in. And who can blame them? It's a magnificent walk with breathtaking views.

The best route lies from Castleton. Park in the centre of the village and head towards Peak Cavern. Don't take the path into the cavern itself; instead head on the route that takes you to Speedwell Cavern with Long Cliff on your left-hand side. This path brings you out at Speedwell, so you can then walk up Winnats Pass or alternatively cross the road and head past Treak Cliff and towards Blue John. From here, either climb back up the old A625 or pick your way to Winnats Head Farm. Your goal is to walk through a small area of woodland at the National Trust car park and then onto Mam Tor itself.

Mam Tor summit looking towards the great ridge.

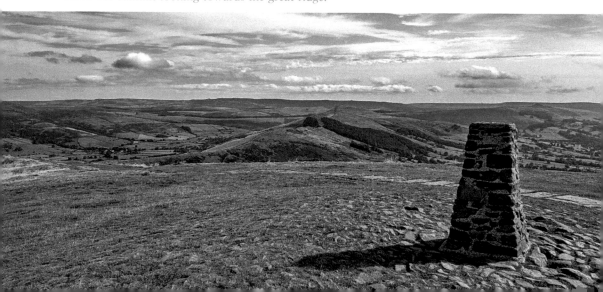

The ridge can be followed all the way to Hollins Cross and Lose Hill before taking the path back down to Castleton. It's a fantastic walk that's probably only a little tricky when you reach Back Tor as it is a little steep there.

Details

As detailed above, Mam Tor (SK127836) can be visited in a variety of ways including being able to park at its base in the National Trust car park. Here, paying for parking is via card only, but it's well worth it.

18. Hope

This pretty but unassuming village is well worth a visit not only for its deli, cafés and pubs, but for its pretty church too. Situated where the River Noe and Peakshole Water meet, and close to Win Hill and Lose Hill, it is an ideal place to take in the Peak while getting to know its history and fabric.

It's not known when Hope was founded but the Domesday Book does note it had a church and a priest in around 1086. The current worship, dedicated to St Peter, was built in around the thirteenth century and has gone through several

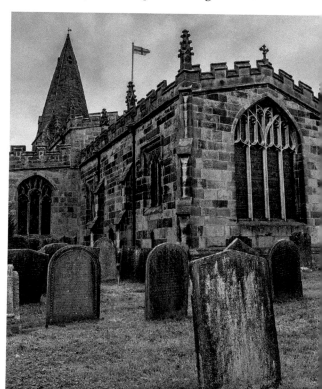

St Peter's Church dominates.

renovations since. Its tower and other features were restored in 1728 and further works took place in the 1880s when new windows, a floor and a clock with chimes were added. Nearly thirty years later, five stained-glass windows were installed by Charles Hadfield of Sheffield.

Walking around the churchyard, there are several artefacts that are well worth seeing. There is the stump of a Saxon cross for starters and on the south side of the church are several gargoyles. The stump of the Eccles Cross is also in the graveyard. There are also thirteenth-century memorials with the symbols of forest officers or 'woodroffes' and inside is a Norman font, a 1652 pulpit, stall backs made from seventeenth-century pews and an eighteenth-century painting that depicts Moses and Aaron.

Hope isn't just about the church, even though it dominates its centre. Nearby is Brough (or Brough-on-Noe), which has the remains of the Roman fort of Navio. According to Historic England it is the best-preserved fort in the area because it shows 'good evidence for the survival of the vicus, a settlement area subsistent on the fort although not part of the military infrastructure'. It is accessible via a short walk from Brough or by following the River Noe down from Hope.

Details
Hope is on the A6187 and isn't far from Castleton. Navio is just a short walk from Hope and although there isn't much to see it is well worth the visit just to take in its heritage. With the church directly in front of you turn left into School Lane and then left onto Pindale Road. From there, at the junction after crossing Peakshole Water, take a left into Eccles Lane and walk a short distance to a footpath sign announcing the route to Anavio. This name is how it appeared on maps from the early 1900s.

19. Hathersage

Much like Hope, Hathersage is, on the face of it, a fairly typical Derbyshire village with not much happening away from its busy village strip. It's bustling, packed with interesting shops and cafés, but a gem? Well, if you scratch below the surface you'll find one, and dig a little deeper and you'll discover several!

Beginning with St Michael's Church, it is thought the present Grade I-listed building dates from the late fourteenth to fifteenth centuries and contains the grave of Little John – Robin Hood's right-hand man. There is a claim that a thigh bone was found on the site in around 1780; the measurements showed he would have been close to 2.5 metres in height – more than 8 feet. Dotted around Hathersage are places associated with the legend: Robin Hood's Cave (on Stanage Edge), Well and Stoop. Elsewhere in the church is an early Saxon

A millstone on the moors above Hathersage. (Image courtesy of Phil Kieran via Shutterstock)

cross, while nearby is a scheduled monument called Camp Green – a Norman ringwork castle from the late eleventh or early twelfth century. It is thought to have been built during the Danish occupation.

Hathersage, or Hereseige as it was recorded in the Domesday Book, was also the inspiration in Charlotte Brontë's books. She visited in 1845 and apparently used it in *Jane Eyre*, taking the surname from a local family. It is also said that North Lees Hall, on the outskirts of the village, was the foundation for Thornfield Hall in the same book – those who have read it will remember that Mrs Rochester jumped from the roof of the hall to her death.

Hathersage was also popular for wire, pin and needle production. In 1566, a German immigrant called Christopher Schutz set up a small works in the village after inventing a way of drawing wire. This would later become bigger than the existing cottage industries that made brass buttons, for example, with needle and pin production blossoming in the nineteenth century. Indeed, there is evidence of Hathersage's industrial heritage up on the moors with several millstones dotted above the village.

That is where we head now too. Hathersage is a busy place, but looking down on it from Higger Tor, you're afforded some tranquillity. It's just over a mile away from the village and well worth the walk to see its gritstone features, as is Stanage Edge, which isn't too far away either.

To the south-east is what is thought to be the Iron Age hill fort of Carl Wark. Experts seem uncertain to its actual origins and usage. One train of thought is it could have been founded in the eighth century BC, but some historians have suggested it could go even further back than that. Evidence points to it being used as a refuge or just somewhere to occupy on a very short timescale.

Back down the village there's enough modern-day trappings to keep you entertained including pubs, cafés and shops. There's even a small factory making cutlery in a strange but inviting looking Round Building. David Mellor Cutlery gives free guided tours at 3 p.m. on Saturdays and Sundays and it's interesting to see how they make this fine tableware.

Details

Hathersage is on the A6187, not far from Castleton and Bamford. Higger Tor is at SK257819 with Carl Wark at SK259814.

20. Stanage

Stanage is one of the most popular climbing venues in the UK. At any time of the year it can be very busy as climbers pick their way up its routes, but don't let its popularity put you off. This is a gem of the highest order, and as it stretches for more than 3 miles from Cowper Stone to Stanage End it's easy to find a quiet spot.

Stanage Edge varies from the cliffs, which include Burbage Rocks and High Neb in the north, to Cowper at the end. The latter is a huge block of gritstone where several hard-grit routes have been established by several hard-grit climbers.

Some of the toughest graded routes can be found here, which is baffling to non-climbers as the cliffs are probably no more than 25 or so metres in height. The difficulty comes from the specialist traversing routes, which can progress into thousands of metres.

Watching these athletes pick their way up is certainly a good pastime, as is the walk to any part of Stanage itself. It's close enough to Hathersage to knock it off in an afternoon, or you can spend most of the day wandering along, enjoying the views. There are grindstones on the hillside showing that the area was quarried and a paved packhorse road along the top. There's also evidence of the Long Causeway Roman road that ran from Brough-on-Noe and there's Robin Hood's Cave, a series of wind-eroded holes that are popular for wild campers. A fine place to be on a summer's evening.

Left and opposite: Stanage is a Mecca for climbers ... and a stunning place for walkers too! (Image courtesy of BMC/Alex Messenger)

Details

There's several ways to get to Stanage, with a minor road that runs from 'Eccleshall in Sheffield via Ringinglow to Hathersage' at the south probably the most popular, according to local websites. Of course, that means parking is at a premium.

The suggestion would be to walk up from Hathersage and then wander along the edge, enjoying the views. Robin Hood's Cave is at SK243837.

21. Bamford Edge

You'll know by now that I like selecting gems that provide great views. Bamford is certainly one of those. For me, it is probably the prettiest in Derbyshire because of the landscape over to Ladybower Reservoir alone.

Much like its Stanage cousin, it is gritstone and very popular with climbers. According to the British Mountaineering Council (BMC) there are 143 routes on it and it was first 'developed' for that sport in 1901.

For walkers, it is possible to make the trip over to Stanage, although official paths – those marked by the Ordnance Survey – are few and far between. Don't let that stop you, though, as this crag was restricted access until the CROW Act.

Enjoy and take in the view.

Details

The BMC say that visitors to crag should only access it by 'the recommend access path'. This is 'beside a lay-by next to an obvious marked gate with a

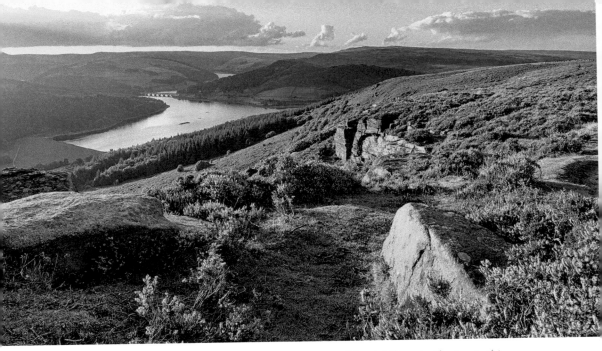

A summer evening at Bamford Edge. (Image courtesy of Daniel Kay via Shutterstock)

stile. Previous guides have mentioned an access point by an iron gate and an old ruin – please do not use this'.

They also note that 'dogs are allowed on public rights of way, but not on the access land to the sides or on footpaths that are not designated as rights of way'.

The crag is at roughly SK207849.

22. Derwent Edge

Continuing our tour of superb Derbyshire Edges, this is another classic that affords a different view of the stunning Ladybower and Derwent Reservoirs.

It has some spectacular natural features too, such as the Salt Cellar, a weathered rock formation that is worth the trip alone. Others include the Cakes of Bread and the Wheel Stones, which resemble a coach and horses if looked at from the A57 that intersects Ladybower at Ashopton.

There's also a viewpoint at Lost Lad, which is at around 1,650 metres on the Edge.

Details
There are several routes to Derwent Edge and it is a popular place, especially in summer. You can walk from Fairholmes visitor centre, at the top of Ladybower,

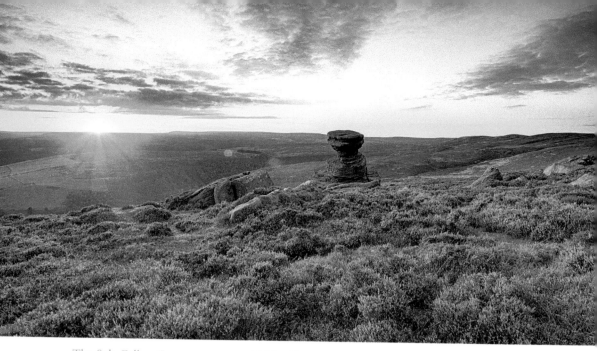

The Salt Cellar. (Image courtesy of Helen Hotson via Shutterstock)

or from a parking spot on the A57 near Cutthroat Bridge. There is also a route from Ashopton too. Either way, the walk is steep but well worth it.

23. Ladybower Reservoir

Ladybower is the most picturesque body of water in Derbyshire and, as a result, the most visited. It was built between 1935 and 1943. Another two years passed before it was filled, and it was then opened by George VI on 24 September 1945.

It wasn't the most popular project, but that is understandable considering its flooding saw the loss of Ashopton and Derwent villages.

Water was a much sought-after commodity in the late nineteenth century. With burgeoning populations in Derby, Nottingham, Sheffield and Leicester, the Derwent Valley Water Board was established to ensure these people could receive a fresh, clean source. Derwent Valley was ideally suited to reservoir construction with its high rainfall, deep valley and narrow places that were perfect for dam building. It also helped that the area had a low population too. The board had already built the Howden (completed in 1912) and Derwent Reservoirs (1916) to satisfy demand but soon that outstripped supply and another was needed.

The new reservoir would be fed by the River Ashop in the west and the River Derwent in the north after it had made its journey through Howden and

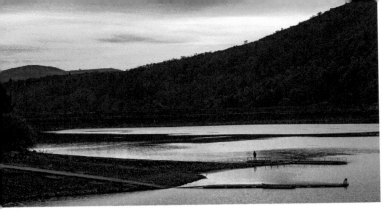

Fishing at Ladybower.
(Image courtesy of
Hahid Khan via
Shutterstock)

Derwent Reservoirs. Of course, there was much opposition to the plan, but it went ahead anyway. Ashopton and Derwent were to be sacrificed.

Those small populations – Ashopton was thought to have less than 100 people within its confines – were moved to specially built houses at Yorkshire Bridge, which can be seen at the southern end of Ladybower, while some refused to move. Both villages still exist with a few dwellings above the waterline.

Moving people when they don't want to is no easy task. The buildings in Ashopton were demolished before the reservoir, but Derwent village didn't suffer the same complete fate and has reappeared from the water in dry summers over the years. The packhorse bridge near Derwent Hall was also moved, piece by piece, to Howden Reservoir and graves at the local church were exhumed then reburied at Bamford.

The dams at Derwent are famous in their own right for playing a part in the 'Dambusters' story. It is worth visiting the west tower too to find out more on this famous piece of history.

Details
There is a car park and visitor centre at Fairholmes (Bamford, Hope Valley, S33 0AQ). The car park is open all year round, with the visitor centre seven days a week (opening times dependent on the season). Here, you can find out the history of the reservoirs and it is the ideal base for exploring Ladybower.

There are also other places to park, such as on the A6013 near Priddock Wood, but Fairholmes is your best bet.

24. Alport Castles

This strange landscape is around half a mile long and baffling to visitors and geologists alike. It's a somewhat chaotic scene – landslips seemingly creating high structures that tower over the valley. From a distance they look like castles – hence the name – and during inclement, dark and cloudy weather they are imposing and almost Gothic.

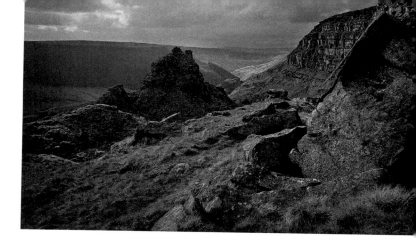

A stormy scene at Alport Castles. (Image courtesy of D. J. Taylor via Shutterstock)

There are several theories that attempt to explain how this 'landslip' was formed. One is that the similar processes that occurred at Mam Tor caused the land to slip away, the soft shales being unable to support the heavier gritstone above. Others are that glaciation created the valley, leaving the slopes on either side exposed and vulnerable to landslips and that water ingress into the gritstone caused the rock above to move and slip. Whatever the theory, it's a stunning place that is matched by the excellent walk from Fairholmes to reach it.

Details

Alport can be accessed from Fairholmes (Bamford, Hope Valley S33 0AQ) and then by picking up the path (signposted to Lockerbrook) and following it past Lockerbrook Farm. Once you have reached Woodcock Coppice, turn right and climb to Bellhag Tor. Continue on this over Rowlee Pasture and along the ridge to Alport Castles (approximately SK142914).

25. Peak Forest

When it comes to visiting Derbyshire, a trip to Peak Forest probably wouldn't be high on everyone's agenda. It is a fairly quiet place on the A623 with a pub and nice church the only real features of note. You'd probably drive through it and not realise you have.

That is probably doing it a disservice. Peak Forest grew from the settlement of Dam, which is on its borders. Its name is probably connected with the Forest of High Peak – a forest covering the north of Derbyshire and a popular royal hunting reserve after the Norman Conquest.

The church is dedicated to Charles I, who was executed in 1649, and was built in 1657. It was rebuilt more than 200 years later in 1878 by the Duke of Devonshire.

But it is one of the 'original' wonders of the Peak we're interested in here, around half an hour's walk from the village. Eldon Hole was one of those original seven, and

while its depths are the goal of cavers, the open chasm is well worth visiting. It is the largest open pothole in Derbyshire at 110 feet by 20 feet at the surface. It descends some 245 feet under the slopes of Eldon Hill and has some fine formations; Phil Wolstenholme's attached pictures doing it more than justice. Further exploration is certainly possible too as there is a local legend that says a goose fell down the hole and made its way out to Peak Cavern in Castleton. That's highly unlikely as modern dye testing would have found that hydrological link by now.

It is thought that it used to be a little deeper too; stones and rubble filled up the shaft over the years. In the report of Mr Lloyd's descent in 1780, he suggested there was a further shaft in the stream at the bottom and the search for this is continuing by various hardy explorers.

Digs are ongoing but were somewhat hampered in 2017 when they found human remains of an adult and child. The explorers had to apply for an exhumation permit for these ancient remains before they could carry on.

Details

Eldon Hole can be found at SK116808. At the crossroads on the A623, heading towards Sparrow Pit, turn right, park and then take the Pennine Bridleway towards Perryfoot. At Elton Farm turn right along the lane, up the hill to Watt's Plantation (SK121808) and then head west. The hole is fenced for obvious reasons!

Above left: One of the wonders of the Peak. (Image courtesy of Phil Wolstenholme)

Above right: Stunning formations. (Image courtesy of Phil Wolstenholme)

26. Padley Gorge

Padley Gorge is a magical place. Located near Grindleford and just off the A6187, it's a deep, narrow valley that nature has taken control of. Tree roots interlock, while the Burbage Brook pours down the Gorge into Derwent Valley and the River Derwent. In places it's tranquil; ideal for the family or to while away an hour. Elsewhere it cascades, especially in wet weather, and is transformed into a dramatic scene.

Its southern part begins near Grindleford station, but it's also accessible from Longshaw Estate, which is managed by the National Trust.

It enters Longshaw at Toad's Mouth and wanders its way through the birches before the topography gets a little steeper and the foliage thicker. There are hidden pools all around, gems in their own right, with the sunlight coming through the leaves to give them a magical quality.

At the bottom you cross a footbridge and can also enjoy a brew and a cracking fry-up at the station before you make you way back up to the top.

There are gems to be found to the north and east of the Gorge too – relics of stone circles such as Stoke Flatt and ancient settlements.

Details

Padley is accessible in many ways and a central starting point of Longshaw Lodge seems the best way of visiting, if you don't mind the walk. Locate S11 7TZ and then use brown signs to navigate to the car parks. Then head west on the many paths.

There's also the option to begin at the Toad's Mouth on the A6187, near Burbage Bridge to follow Burbage Brook down. This is probably a more organic route to see how the gorge develops and parking exists in lay-bys to the west to help.

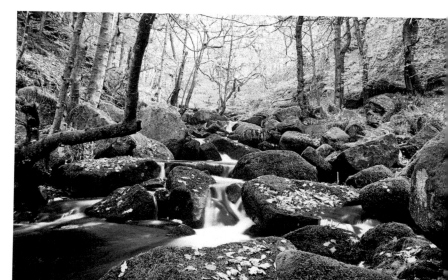

Padley Gorge in its autumn glory. (Image courtesy of Ste Mack via Shutterstock)

South-East

27. Tideswell

When Michael Drayton named Tideswell as one of his wonders of the Peak, it was the Ebbing and Flowing Well that drew his praise. The poet liked the way the spring moved in a tidal fashion and it is thought the village drew its name from this phenomenon.

The well now sits in a private garden. It seems evidence for its tidal aspect is actually purely anecdotal and such occurrences came in periods of heavy rain. It is likely this, alongside an underground reservoir of some sort, meant the water appeared to rise and fall.

The other theory is that an Anglo-Saxon called Tidi founded the village more than 1,300 years ago. 'Tidi's spring or stream' connects it to the existing moniker and many people accept this as the story behind the village's name.

Tideswell is a market town that was historically known for its lead mining. It gained its market charter in 1251 and points to that heritage with its Tideswell Made scheme. It is a trust mark, which demonstrates that the products sold here are first class – a symbol of quality. Taste Tideswell is another scheme that aims

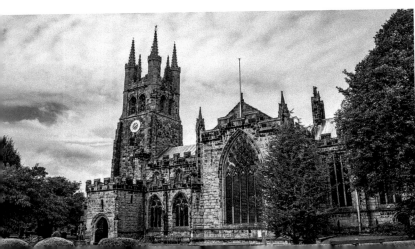

Tideswell's church is the 'Cathedral of the Peak'. (Image courtesy of Millie Appleton)

to connect locals and visitors to its businesses. It includes a food festival and other ways of making the area a real destination for food.

History is key in this part of the world, and Tideswell is proud of its past. Walking by the church and towards an 'S' bend in the road is a circle, set off the main road, which features stories of Tideswell's past. It has audio clips and several displays depicting how the village used to be. It's also said that this village has several haunted places. The ghost of Old Sarah, a Victorian server, has been seen at the George Hotel. Apparently, she wears a long dress and cap. The former Catholic chapel on Church Street is said to have a secret passage to the new church too.

The Church of St John the Baptist dominates Tideswell and it's no surprise that it's referred to as the 'Cathedral of the Peak'. Built in the fourteenth century, it is a fascinating place that includes many historical features, which can only be appreciated by a visit.

The nave, aisles and transepts were built in the 1340s, while the tower was added at the end of that century. In the centre of the chancel is the altar tomb of a local knight, Sir Samson Meverill, who died in 1462 while local landowner John Foljambe's tomb is in the floor nearby. The carvings in some of the pews are intricate too.

Details
Tideswell can be found on the B6049, just off the A623 close to Litton and Great Hucklow. The church is open daily from 9 a.m. to 6 p.m.

28. Eyam

In 1665, Eyam's history was changed forever when the bubonic plague – the Black Death – visited this quaint village. It is thought to have arrived in a flea-infested cloth from London that was destined for a local tailor. Within a short space of time, after it had been hung out to air, his assistant George Vicars died and the rest of his household soon followed. The plague then spread through the village, wiping out generations of families.

Stricken with panic, Eyam was placed in quarantine, thanks to the actions of Revd William Mompesson and Puritan minister Thomas Stanley. Alongside their congregations, they agreed that no one should enter or leave the village, and religious services and other meetings be held in the outdoors some distance from its centre. Food and medicine would also enter the quarantined area through a boundary stone, which would mark the line between the infected village and the parishes around it.

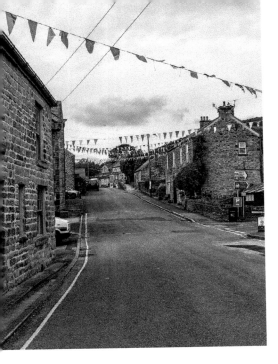

Getting ready for the well-dressing festival.

One such stone was located near Stoney Middleton and it contained six holes that were filled with vinegar. It was an effective disinfectant that allowed villagers to exchange money with the outside world for goods. Mompesson's Well was another site of 'cleansing', with the water acting much like the boundary stone in stopping the spread of infection. Other plague stones marked the village's boundary – a warning to those who may have wanted to enter.

By 1 November 1666 more than 270 people had died of the disease, but their act of self-quarantine certainly saved the infection being spread to other villages. Their unselfishness, alongside the tragedy, is commemorated every Plague Sunday (usually the last Sunday in August) at Cucklett Delf in Eyam. This was where outdoor services were held during the quarantine. The event began in 1866.

A walk around the village brings you into direct contact with this terrible part of Eyam's past. Plaques adorn buildings to mark who died there, such as the house of George Vicars. To the east of the village are the Riley graves, where seven people are interned. They are the graves of Elizabeth Hancock's husband and six children, who she had to bury over the course of eight days, but remarkably she survived. Mompesson's Well is to the north.

To get a feel for the story, it is well worth visiting Eyam Museum, which was inspired by Clarence Daniel. He collected archaeological material and documents on the village, housing them in a small museum in his own home. When he passed away in 1987, those important parts of history were given to the Village Society and now form the basis of the museum. It also tells the story of how Eyam got back on its feet after the plague.

If you coincide your visit with the annual Well Dressing Festival, then you can watch volunteers create colourful and detailed murals that adorn local wells. Well dressing began in pagan times to celebrate pure and clean water and was

Dressings being prepared.

likely resurrected in the mid-seventeenth century by those villages that didn't suffer from the plague.

Eyam means 'village by the water', and was known as 'Aiune' in the Anglo-Saxon period. Once the plague had left its confines, it no doubt joined other parishes in celebrating this life resource.

Even before the plague, water was already a crucial element in village life. The Hall Hill Troughs near Bradshaw Hall, established in 1588, provided water to the local populace and are said to be one of the first public water supplies in the country. They did this for nearly 350 years before more modern ways of delivery were used.

The depictions on the well dressings are fantastic. Flower petals and leaves, among other bits of foliage, grasses and mosses, are pressed into a thin layer of clay that is set into a wooden frame to create a large image. These can be inspired by a multitude of things, including scenes from the Bible, local history or other worldly events. In 2017, the well dressings were based around J. R. R. Tolkien to mark the 125th anniversary of his birth.

Elsewhere in the village is the twelfth-century Church of St Lawrence. It has an original font and Norman pillars, as well as an eighth-century Celtic cross. At the time of writing, the National Trust's lease at Eyam Hall and Craft Centre had ended. This Jacobean manor house was built by Thomas Wright in 1672 and was taken on by the National Trust in 2012 with the aim of creating an outdoor hub. It has now returned to the Wright family, with the Craft Centre and shops remaining open.

Details

From Tideswell, take the B6049, head to Foolow and then follow the road to Eyam. The village is also accessible from A623 if coming from Stoney Middleton and turning right onto the B6251.

You can find the opening times at Eyam Museum by visiting www.eyam-museum.org.uk or calling 01433 631371. The website for Eyam Hall is www.eyamhall.net.

Mompesson's Well is located at around SK221772. The boundary stone is best seen on the path from Stoney Middleton to Eyam at SK226758. There are three other plague stones noted on the Ordnance Survey map too, which act as a marker of the village's 'infection' boundary. Cucklett Delf is located to the south of the village at approximately SK216760.

29. Monsal Trail

The Monsal Trail follows a section of the former Midland Line that was closed in 1968. It was unused for nearly twelve years before the Peak District National Park took control and created a route through some of the most spectacular scenery in Derbyshire.

It is around 8.5 miles long and, more importantly, traffic free – aside from the occasional horse, that is. Walkers, cyclists and horse riders can enjoy a route that runs between Blackwell Mill in Chee Dale and Coombs Road at Bakewell, and through the tunnels used by the trains.

This may not sound the most exciting thing to do but they are well lit (during the day anyway) and offer something a little different from a normal trail. You can also cross several viaducts above the River Wye that offer different views into the Peak's most natural landscapes and dales. The trail passes through Miller's Dale, Monsal Dale and Upperdale, for example.

It isn't just the environment that is celebrated on the trail; stations along the route are impeccably looked after and there are plenty of things to do and read that give a context of what is going on around you.

This is a railway line that had plenty of objections when it was built in 1863. It had to be rerouted, for instance, because the Duke of Devonshire didn't want it passing through his grounds such as Chatsworth House. Therefore, it had to go to the north-east of Bakewell rather than taking the more direct – and probably more sensible – way, which would have taken it through the duke's grounds. Other objections saw one of the tunnels, Haddon Tunnel, built to hide the line from the view of wealthier landowners.

Details
There are plenty of access points to the trail, including Bakewell, Hassop station, Monsal Head and Millers Dale. The latter is a gem as it is not far from Chee Dale – a fantastic walk away from the trail in its own right. For further details visit www.peakdistrict.gov.uk/visiting/trails/monsaltrail.

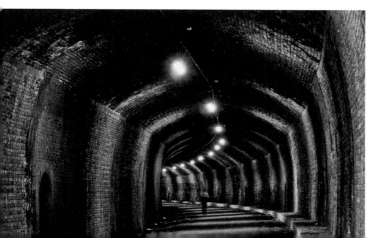

One of the tunnels. (Image courtesy of Peak District National Park Authority)

30. Chatsworth House

To include Chatsworth in a book of Derbyshire gems is one of the easiest choices to make. It is a vast stately home, set inside some of the best-kept grounds in the country, and houses shops, places to eat and lots to do for all the family.

Chatsworth is set within a 35,000-acre agricultural estate and a visit here is a no brainer. While entry to all its attractions (and I use that term loosely, as this isn't an amusement park) might be expensive for some budgets, there's still a level to suit all. For instance, entry to the farmyard and playground is priced at around £22 for the family. In this day and age there aren't many places you could go to match that value.

Chatsworth is steeped in history and popular culture. It appears in *Pride and Prejudice* and has been the scene of many films and period dramas. The current Duke and Duchess of Devonshire are keen to see that blend maintained and enhanced for future generations. The house was designed to be 'modern' whatever the era. It's elegant, current, clean and inviting, but the ravages of time mean basic general maintenance isn't an option. At the time of writing, a £32.7 million master plan was coming to its end, which involved major renewal and renovation work – arguably the most extensive since it was built.

Noticeable renovations have seen the stonework on the house cleaned and repaired. There have also been conservation efforts in the four faces of the courtyard, new galleries and a major redisplay of the Devonshire's collection. Old Master drawings are now also exhibited on rotation in a purpose-designed room called the Old Master Drawings Cabinet. These match other more modern art installations as well as an array of artefacts, sculptures, books and documents.

The house was originally built by Elizabeth Talbot, the Countess of Shrewsbury, in the 1560s. Bess of Hardwick, as she was known, married Sir William Cavendish in 1547 and her subtle persuasion saw them move to her home county. Despite being an isolated place and rather flood-prone, they bought Chatsworth manor for £600 in 1549, and three years later began to build the first house. By the time the 3rd Earl of Devonshire preceded over the estate, it had been occupied by both sides in the Civil War (1642–51) and was becoming outdated and unsafe. The 4th Earl didn't gain his title until the age of forty-three, but when he did he began to look at this issue, and the repair of the house.

Initially, he wanted to repair the south front, but went one step further by pulling it down in 1696 and replacing it with family rooms and an opulent apartment. Soon after, he ordered the rebuilding of the east front, followed by the west and finally the north. William Talman, a pupil of Sir Christopher Wren, was the architect of the south and east fronts. The new-look house was completed in 1707.

More than fifty years later, the 4th Duke of Devonshire made changes to the park and garden. He demolished the stables, offices and some of the cottages of the nearby Edensor village, which were visible from the house – all because he believed

Chatsworth should be approached from the west! James Paine built new stables and designed a new bridge too. Lancelot (Capability) Brown replaced the original formal garden and park with a natural feel, which was more fitting with the times.

The 5th Duke of Devonshire allowed the house to be open to the public in the late 1700s or early 1800s and once a month those visitors would be given dinner. He also commissioned John Carr of York to alter the decoration and furnishings of the first-floor drawing rooms, and to build the Crescent in Buxton.

The 6th Duke, William Spencer Cavendish, continued the changes too, but this time focus returned to the gardens. Joseph Paxton was appointed head gardener at Chatsworth in 1826 and they introduced more exotic species and rockeries. William also commissioned Paxton to build a spectacular waterfall to impress Tsar Nicholas I of Russia, who was considering visiting the house in 1844. It would be the world's highest, bigger than the one at Peterhof, which was the Tsar's palace in Russia. An 8-acre lake, the Emperor Lake, was built on the moors above the house to feed it. Sadly, the Tsar never visited Chatsworth, but the Emperor Fountain remains in his name. It is very impressive; it is on record as having hit a height of 90 metres, although presently it reaches around 60.

Now the 12th Duke, Peregrine Cavendish, and his wife Amanda Heywood-Lonsdale are overseeing the master nplan and continuing that lineage of protection and enhancement.

Details
Chatsworth is well signposted and can be found at DE45 1PN if using a satnav. Various ticket options are available and it's best to log on to www.chatsworth. org to find out more. It operates seasonal opening times – again, it is best to check the website.

Chatsworth House Bridge. (Image courtesy of Simon Annable via Shutterstock)

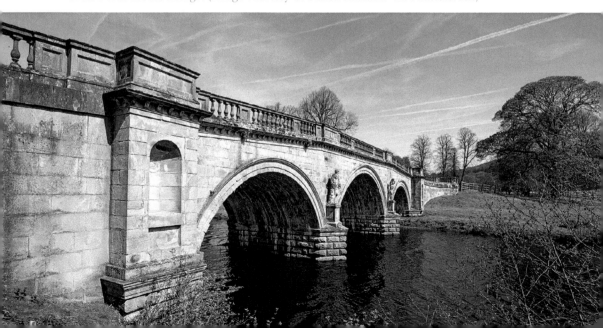

31. Edensor

Edensor was originally situated between the River Derwent and the road through Chatsworth, with some of its houses set out in a line down to the water. However, the 4th Duke of Devonshire believed the house should be approached from the west and after investing a significant amount in improvements and a new bridge, ordered these dwellings to be demolished. The inhabitants were moved to nearby villages of Pilsley and Beeley and the duke's vision of the grounds and the Chatsworth estate – in his mind – were improved.

The remnants of the village and its tenants remained until the 6th Duke decided to build the new one that exists today. He didn't like what was left of Edensor and, more importantly, the view of it from Chatsworth, so relocated it over a hill and out of sight.

It was planned by the duke himself and Joseph Paxton, who had been instrumental in redesigning the gardens at Chatsworth in 1826. They also utilised the expertise of the house architect, John Robertson. Their role was to keep it in the manner of the estate: modern and inviting, which it is. As a model village it is pretty, quaint and definitely unique. It feels experimental as there are a variety of architectural styles – from Tudor and Swiss Cottage to Italian-style villas. At the heart is the Grade I-listed St Peter's Church, which replaced an older twelfth-century site of worship. Robertson could have easily demolished it and no doubt reconstructed something in keeping with the new-look village, but he chose not to.

The 7th Duke of Devonshire had other ideas, however, and between 1867 and 1870 it was rebuilt under plans drawn up by famous Gothic Revival architect Sir George Gilbert Scott. Thankfully, the style was in keeping with the village and it dominates the area, providing a real focal point. It features the interment of the family's graves, alongside many other memorials. In the churchyard is also the grave of Kathleen Kennedy, the sister of the late president of the USA. She married the 10th Duke's oldest son, William, Marquess of Hartington, in May 1944 but just four months later he was killed in Belgium while serving with the Coldstream Guards. Sadly, Kathleen died in an aeroplane accident in 1948.

A trip to Edensor should finish with a brew at the Edensor Tea Cottage too. What a place that is!

Details
Edensor can be found by navigating to the postcode DE45 1PH – just off the B6012.

32. Ashford-in-the-Water

Edensor may have been designed as a model village, but Ashford-in-the-Water is an original catwalk star – one of the prettiest in the country. It's a chocolate-box scene, with beautiful idyllic houses and buildings alongside a medieval packhorse bridge that is sure to be one of the most photographed in the area.

In the Domesday Book the village is referred to as 'Aisseford' and it's thought the addition of 'in-the-water' referred to the fact it was on the banks of the River Wye. It was also part of the Cavendish family's estate in the sixteenth century and remained a hub of lead mining until the nineteenth century. From that period, a cottage industry grew around the use of a dark limestone that was mined on the edge of the village at Rookery Wood. It turned jet black when polished and the resultant 'Ashford Black Marble' was used for decorative purposes.

Many of its buildings are listed; one in particular is the Sheepwash Bridge. It is near the site of an original ford and until recent times sheep would be bathed in the river before being sheared and penned in the stone-walled enclosures on the other side. Ewes were pushed into the river, ducked and then made to swim downstream to join their lambs on the bank.

It's easy to spend a lot of time at the bridge wondering how cold it must have been for those shepherds and how scary it must have been for their flocks, too, while this process took place – the river moves at a fair pace! However, it is a quiet place, which is surprising given its close proximity to the A6.

Moving further into the village, which has a fantastic shop and pubs, it's not long before the Church of the Holy Trinity appears. It is of Norman origin with some later additions dated around 1870. Part of the tower was built in the thirteenth century and it also contains a Norman tympanum, carved with animals over the door inside the porch. There's also the stump of a Grade II-listed cross in the churchyard and preserved maidens' garlands. These were carried at the funerals of unmarried girls.

Details
Take the A6 from Buxton and, before you reach Bakewell, Ashford-in-the-Water is signposted. It is best to park near church, which is also signposted.

A place for well dressing.

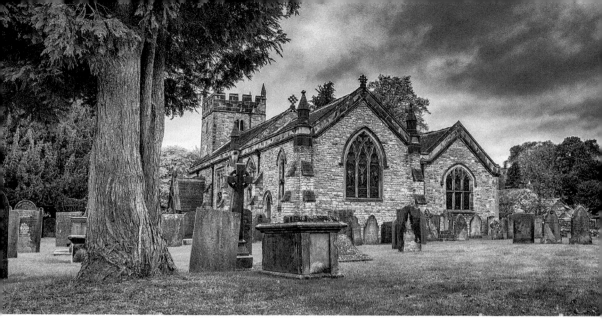

Above: Church of the Holy Trinity.

Right: A medieval packhorse bridge.

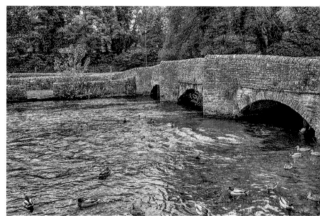

33. Bakewell

Considering its small size, Bakewell packs a punch in not only what there is to see and do but how that is intertwined with a modern town. Bakewell is a busy market town, a honeypot for visitors (and traffic, sadly, but that shouldn't detract you from visiting).

It is, of course, famous for its pudding and doesn't shy away from it either! There are several bakeries and eateries that make the great-tasting pudding and it's up to you to decide which one is best. By way of a recommendation, I went for Bloomers on Water Lane. The bakery is housed in a building dating back to the 1600s and claims to serve the 'first and only original Bakewell pudding',

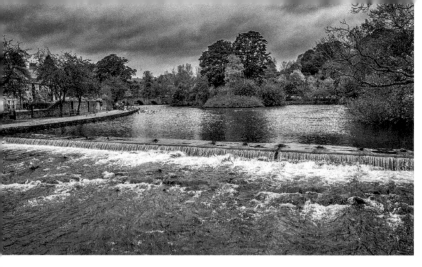

The River Wye runs through Bakewell.

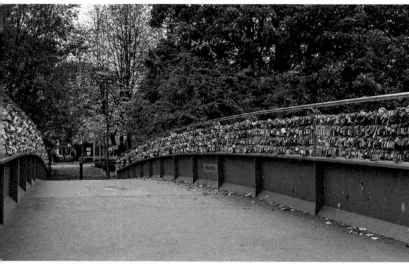

Love locks on the bridge.

with a recipe dated from 1889 that was handed down over four generations. It's delicious too and the bakery also does internet orders.

The pudding – which has a moist almond and jam filling – is said to have come about by a mistake by a kitchen maid who was tasked with making a jam tart. Instead of stirring eggs and almond paste into the pastry, she spread it on top of the jam. The local story says this took place in around 1860 at the then White Horse Inn and the misunderstanding was between Mrs Greaves, mistress of the inn, and her cook. It's suggested that the inn was demolished more than fifty years before this occurred, so it seems unlikely, but is a great story nonetheless.

That originality is important to Bloomers, and the Old Original Bakewell Pudding shop too. On its website it claims that the resultant pudding 'was so successful that a Mrs Wilson, wife of a tallow chandler who lived in the cottage now known as the Old Original Bakewell Pudding Shop where candles were made, saw the possibility of making the puddings for sale and obtained the so-called recipe and commenced a business of her own'. Whatever the truth, the simple fact is the pudding is unique to Bakewell, and people come from miles around to taste it.

Bakewell's church, All Saints, was founded in 920, which suggests the town itself was probably Anglo-Saxon, though there is evidence of much earlier settlements nearby. The present church was constructed in the twelfth and thirteenth centuries, before being rebuilt in the 1840s. It is Grade I listed and has two Saxon crosses in the churchyard: the incomplete Beeley, which stands at more than 5 feet high, and the complete Bakewell Cross, which is 3 feet higher. It was carved in the seventh or eighth century and you can see a number of pictures within it. A ghost tale says that a fifteen-year-old Prince Arthur, the son of Henry VII, saw a woman in white beneath one of these crosses. She foretold his early marriage and early death, and within four months they had come true.

A market charter was given to the town in 1254; the market still takes place on Mondays, selling a variety of goods.

A more modern introduction to the town is Lovelock Bridge, which crosses the River Wye. These bridges have been appearing all over the country in recent years, as couples and families attach padlocks to them to symbolise their togetherness. This version seems in keeping with its surroundings. You can view the locks and then look over the River Wye towards the medieval five-arched stone bridge opposite.

Details

Bakewell can be visited in a number of ways and is off the A6 on the road from Buxton to Matlock and Derby. Parking is best near the five-arched bridge.

Details on Bloomers can be found at www.bloomersofbakewell.co.uk, and the Old Original Bakewell Pudding Shop at www.bakewellpuddingshop.co.uk.

34. Haddon Hall

Haddon Hall dates from the eleventh century and describes itself as 'probably the finest example of a fortified medieval manor house in existence'. It's a moniker that couldn't be more correct too: the manor house is set within beautiful grounds that are impeccably kept, while the inside is exquisite and fitting with its historic nature.

The fortified medieval manor house, based south of Bakewell, is built around two courtyards with a Long Gallery and Great Hall, plus the Peverel Tower – its main features. It was enhanced by subsequent generations of the Vernon family until the seventeenth century. The kitchens and parlour date from around 1370, while the St Nicholas Chapel was completed in 1427.

Currently, Lord and Lady Edward Manners reside within the hall and they have ensured that the income generated from visitors is reinvested back into Haddon through a significant restoration project. Three fifteenth-century

windows in the chapel were restored in 2004; eleven years later the windows in the Long Gallery and Ante Room, overlooking the upper courtyard, were too.

William Peverel held the manor of Haddon in the eleventh century, but it was not until the end of that century that it was enclosed by a wall. It had to be specifically decreed by licence because the hall wasn't a castle; for this to happen it must have been a significant building in terms of stature and importance.

By that time the Crown had acquired it from Peverel and later it was passed to one of his tenants, the Avenell family. Sir Richard de Vernon and Alice Avenell, daughter of William Avenell II, were married in the twelfth century and from there the Vernon family were ever present until the sixteenth century. Then, Dorothy Vernon (the daughter and heiress of Sir George Vernon) married John Manners, the second son of Thomas Manners, who was the 1st Earl of Rutland. Their descendent John Manners was made the 1st Duke of Rutland in 1703, but decided to reside in Belvoir Castle, meaning the connection between him and his subsequent descendants, and Haddon, was lost.

It wasn't until the 9th Duke of Rutland, John Manners, saw the hall's importance that it became inhabitable again. He began its restoration in the 1920s and created the walled topiary garden next to the stable block. It is now

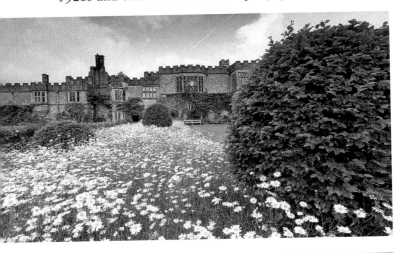

Some of the grounds. (Image courtesy of Haddon Hall)

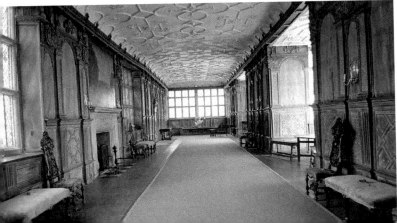

The exquisite interior. (Image courtesy of Haddon Hall)

occupied by Lord Edward Manners, brother of the 11th Duke of Rutland, and it was Lady Edward who kindly allowed us to display these wonderful images.

Details

Haddon Hall (DE45 1LA) can be found by taking the A6 south out of Bakewell and then by following the signs. To find out more head to www.haddonhall.co.uk.

35. Hartington

At the northern end of Dovedale is another picture-perfect village with a deep heritage. Hartington, which derives from 'stag's hill' or 'hill connected with a stag or Heorta', was mentioned in the Domesday Book as belonging to Henry de Ferrers and being worth 40s. It was granted a market charter in 1203 and became a focal point for the many isolated farms around the area.

The market doesn't exist anymore but the wealth it brought to the village can be seen in the stone cottages and houses around the village square and duck pond. Hartington Hall, dating back to 1611, is now a local YHA, and there's the Charles Cotton Hotel, the thirteenth-century St Giles Church and Market Hall too.

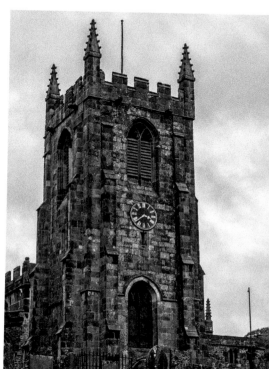

St Giles Church.

There used to be a cheese factory or creamery in the village, which was founded by the Duke of Devonshire in 1876. It produced its own Dovedale cheese and stilton too, which ceased in 1895 before reopening five years later. It apparently produced a quarter of the world's supply of Stilton at its height, but closed after being sold in 2009. The Old Cheese Shop pays tribute to this past and it has begun to make its own products once again.

It's also worth venturing to Arbor Low, which is signposted near the village. It is a Neolithic stone circle monument set in high moorland.

Details

Hartington is on the B5055 near Longnor and Hulme End. The Old Cheese Shop is open seven days a week from 9 a.m. until 5 p.m.

36. Matlock Bath

Matlock Bath has to be one of the most bizarre places I have visited on my tour of Derbyshire. We've discovered rolling dales, stunning ravines, glistening rivers and quaint villages ... and then we roll into what looks like a Swiss resort but with arcades and fish and chip shops. It doesn't seem in keeping with Derbyshire, but following a simple stroll along the river it's easy to discover it has a real charm that wouldn't work anywhere else in the country.

Matlock Bath's popularity began in the nineteenth century when it was developed as a spa town. Warm springs had been originally been discovered at the end of the seventeenth century and a simple bathhouse was constructed. After a while these became more popular and Princess Victoria of Kent, in 1832, confirmed it as a venue of the time for those that were well to do. It was a recommendation you just couldn't buy and subsequently the likes of John Ruskin and Lord Byron all came to the area, each enhancing its reputation. It was also dubbed Little Switzerland in Victorian England. That heritage is still celebrated and preserved. Matlock Bath is a designated conservation area and property development is restricted, particularly along the North and South Parade.

The walk along the River Derwent at Matlock Bath is not to be missed. Each year around autumn time it is lit up with special illuminations and boats along the Grade II-listed Lovers' Walks, which adds a touch of romanticism to a stroll. You can join these walks at a number of points along the promenade, but via the 1887 Jubilee Bridge is the best access point. The walks are known to have been in existence prior to 1742 and are thought to be the oldest continuously used public pleasure ground in the country.

The original part of this was a riverside path, reached by boat. It led to the cascades, which are a natural waterfall from a thermal spring. Another path

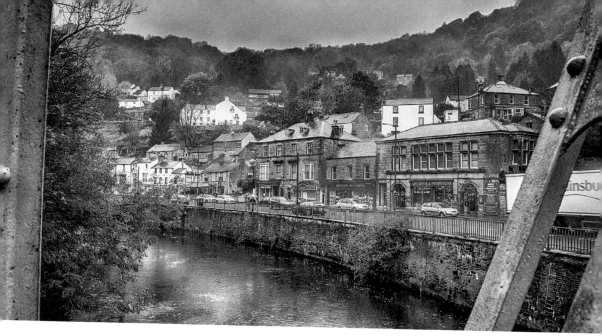

Above: Matlock Bath from Jubilee Bridge.

Right: Head down Lovers' Walks.

from those cascades led visitors to the top of the cliff, some 200 feet higher, on the left-hand side of the path. It is thought these were decorated with urns and ornaments too, adding to their class. These days, it is possible to take four routes through the ancient woodlands to the clifftop.

Matlock Bath also features the Peak District Mining Museum, which is housed within the rather abstract Edwardian Grand Pavilion.

Details
Matlock Bath is fairly simple to find. It is on the A6 from Bakewell, and there is plenty of roadside parking.

37. The Heights of Abraham

The Heights of Abraham are, according to its operator, the Peak District's oldest tourist attraction. They first opened as a 'savage garden' in 1780 'when visitors would make the climb from the valley floor on foot to witness the breathtaking views across the surrounding area'. Historic England notes its development as some six years later, with its name coming from a supposed resemblance to the Heights of Abraham at Quebec, which were scaled by Wolfe in 1759. It was opened by the Simpson family, who laid the path on the steep Masson Hill and advertised it as 'walks to the Heights of Abraham'.

George Vernon bought the estate in 1797 and in 1808, when it was owned by Benjamin Wyatt, the Lower Towers were constructed. The Upper Tower House was added around 1830 by Dr Jonathan Gilbert in a Gothic style – much like the earlier buildings on the site. He was also responsible for opening a show cavern in 1810 when he developed the Nestus lead mine, which is now called the Rutland Cavern. This and the Masson Cavern can be visited at the top. Both contain large caverns and fascinating histories. Masson exits the surface near Tinkers Shaft and there is a fantastic viewpoint there that is well worth seeing.

The method of reaching the summit has changed since it was originally opened. Yes, you can still walk up the zigzagged path for it if you like; alternatively, you can take the cable car. It took until 1984 before visitors could do this and it is well worth it. The vista is outstanding and your admission price covers all the attractions at the top too. Historically, the site is a romantic snapshot of the mindset of the nineteenth century and you can see why they pulled out all the stops. The railway revolutionised transport and brought people to Matlock

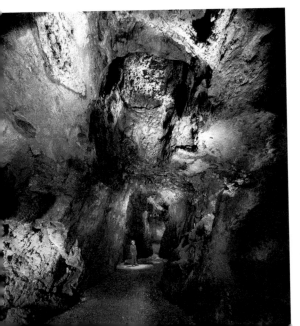

Masson Cavern. (Image courtesy of The Heights of Abraham)

View from the cable car.
(Image courtesy of The
Heights of Abraham)

Bath because of the Heights and the fact it was a spa town. In return it put on a show. The town was a pleasure stop and organised excursions via the railway made it very popular.

At the Long View Exhibition, you can find out why the Heights have been so popular for the last 230 or so years. On the floor above there is a Fossil Factory, which is ideal for the youngsters in your life. Other exhibits include a pictorial journey of the Peak District from the air and the Victoria Prospect Tower, which was built in around 1844. It was constructed to provide employment for lead miners who had lost their jobs on hillside when the estate had become a 'Pleasure Ground'. It was restored in 1978.

The Heights also has two fun areas for kids to play in and the really good Vista Bar & Restaurant and Terrace Café.

Details

The Heights of Abraham are in Matlock Bath (satnav: DE4 3PT). Admission at the time of writing was: adult £16, child £11, senior (over sixties) £12.80, with family tickets also available. Travel by rail and you will receive a 20 per cent discount too. www.heightsofabraham.com.

38. Lumsdale Waterfalls

Lumsdale is a real hidden gem near Matlock; a blend of just how nature takes its course over the passage of time and a snapshot of how life used to be.

Watermills harnessed the narrow Bentley Brook for power. They are frozen in time, with the stream making its way down through the old workings to join the River Derwent at Matlock.

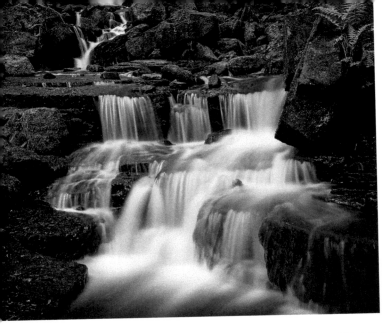

Approaching the brook from the A632, near Highfields School and walking south, you can see the remains of a bone mill, which was likely built in the sixteenth century and provided ground bones for fertiliser. From there is a second, which houses a millstone that was imported from the Massif Central in France. The Paint Mill follows, then one that was used to grind lead and corn. The Upper Bleach Mill and finally Garton Mill, which was built around 1785, follows. These are maintained by the Arkwright Society, who have done a sterling job in keeping it in accordance with the wishes of former owner Marjorie Mills, who passed away in 1996.

Details

The Lumsdale waterfalls are just outside Matlock and can be accessed from a lane that links the A615 and A632. There are plenty of footpaths in the area, so a suggested walk would be to park up in Tansey and walk to the west. Alternatively, walking from the A632 near the school to cover a north to south route would also be worthwhile.

39. Dovedale

If you're looking for a natural gem that has so much to offer within a short distance, then Dovedale is for you. Simply don your walking boots and, for a little effort, at around half a mile, you'll find the River Dove working its way through the landscape with steep-sided hills on both sides before you reach

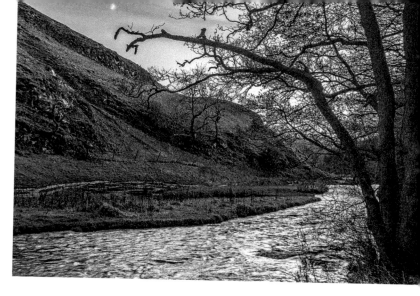

Dovedale is beautiful. It is captured here as the dusk arrives ... and a fair amount of water too.

picturesque stepping stones. Such is the quality of this gem that you need go no further. But you'd be mad not to.

I visited Dovedale one autumn evening as the River Dove was beginning to overflow. It created some tricky walking and wading conditions, but that didn't matter as all I could hear was the rush of water, wind coming off Thorpe Cloud (some 287 metres high) and birds singing. This is the best time to visit Dovedale. It is a busy place, usually, but there's plenty of solitude as dusk approaches.

As I made my way up the path, the moon was beginning to peak through the dulling blue sky and the temperature had dropped to leave a slight mist in the air. The river was creating its own path too, ignoring its traditional boundaries as it cut through the landscape.

Soon, the vista in front of me also opened up. The River Dove bent to the left as the stepping stones, now barely visible above the surface, went right to join the path on the other side. Ahead was steep ground, trimmed by sheep, and a strong breeze causing the water to lap ferociously on the surface. A couple were taking selfies on the stones but hadn't realised that where there was once rock there was now water, and not a great deal visible underneath. They made a hasty retreat to the left side of the path, pausing to have another picture before disappearing on the route I'd come from.

Crossing the stones was entertaining, but once on the other side I picked up the pace. Soon Lover's Leap came into sight – a jutted part of the landscape that is a popular place for pictures. The story says that during the Napoleonic Wars a young woman, on hearing her man had been killed, climbed to the top and attempted to commit suicide. Lucky, her skirt became caught on some branches on her dramatic way down and she was able to retreat back to safety. When she returned, she learnt her chap wasn't dead after all and was on his way home to see her. It's a nice story, whereas the route we're now on isn't perhaps so pleasant historically; the steps were built after the Second World War using Italian prisoners of war.

After a short while, Reynard's Cave comes into view and it's an impressive sight. It's a short climb up from the main path, as is a large natural arch that

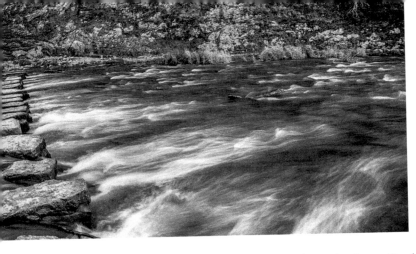

The famous
stepping stones.

was thought to have been inhabited in prehistoric times. To the left is a smaller cave called Reynard's Kitchen. Artefacts from the Bronze Age and late Iron Age were found on this site, and excavations here have also found Roman coins. There are other smaller caves further along the walk, until you arrive at Dove Holes – and you won't want to miss them – which are impressive entrances set into the hillside.

Walking further along the path and you can see Ilam Rock and Nags Spring, among other natural features, before arriving in Milldale. But with light fading I decided to pick my way back to the car park. Returning, you get a different view of the landscape as the river is on your right. Opposite Lover's Leap is the Twelve Apostles – rock spires created from harder reef limestone. The river has eroded the rock and soil around them and they stick up from the side of the valley. They are an amazing, impressive and imposing sight. As is the whole of Dovedale.

Details
Follow the signs from the A515 to Thorpe and then take the road to Ilam Country Park. Before reaching this, turn right at the sign and park at the official car park. You will need stout boots if it has been raining!

40. Tissington Hall

Tissington is a beautiful village just off the A515, north of Ashbourne. It is part of the 2,000-acre estate of Tissington Hall, which has been in the same family for more than 400 years.

The hall was built in 1609 by Francis FitzHerbert to replace the moated fortification that guarded the Norman Church of St Mary's in the centre of the village. Its main part houses the hall, dining room and two state drawing rooms, with many other rooms and wings added since it was constructed. Joseph Pickford began the main additions in the eighteenth century and in 1900,

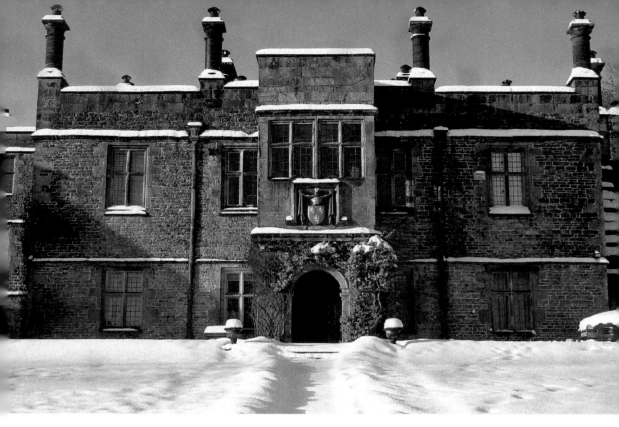

Above: Tissington in the snow. (Image courtesy of Sir Richard Fitzherbert)

Right: Hall Wall.

Arnold Mitchell built the library and billiard room. The current inhabitants are Sir Richard FitzHerbert, who inherited the hall and estate from the late Sir John FitzHerbert at the age of twenty-four in 1989, and his wife Fiona.

'I inherited a great many wasting assets and wanted to make them "sweat" so I strove to bring new industries and workshops into the village to create jobs that had been lost locally on the farms,' he says. To be fair, he has done just that. In total, there are forty-six residential properties, many of which are listed.

There are 40 acres of woodland too and several farms that produce dairy, sheep and beef. One of the first things Sir Richard did was to convert the old coach house in the centre of the village into a tearoom. That opened in 1997, winning awards a couple of years later for Best Conversion of Redundant Buildings. The Kitchen Gardens were turned into a small-scale nursery in the early 1990s and other small businesses include a butchery, candle-makers and craft shop.

Any visitor to Tissington won't fail to notice the number of wells, which continue to provide some of the cleanest water you will see and taste. In the past these would have provided villagers with their supplies and, much like other parishes, are celebrated through the annual well-dressing ceremonies. Folklore says that while other villages suffered from the Black Death, Tissington was kept free of the disease because of the purity of the water supply.

In 1615 there was a drought: 'There was no rayne fell upon the earth from the 25th of March until the end of Maye, and then there was but one shower. Two more showers fell between then and the 4th of August, so that the greater part of the land was burnt up, both corn and haye'.

Yet, with other parishes struggling and losing livestock, the five wells in Tissington continued to flow and it became customary to dress these in later years in a celebration of thanksgiving. They're constructed in much the same way as the ones at Eyam, using local clay and flowers. The dressings are erected on the eve of Ascension Day and then blessed following a church service. They will then stay in situ for under a week.

Well dressing takes place during May each year and it is worth checking out the Tissington Hall website to find out the exact dates.

Details
Tissington is just off the A515 heading from Buxton, north of Ashbourne. www.tissingtonhall.co.uk.

41. Chesterfield

Chesterfield is a market town that was granted its status in 1204 but has Roman origins dating to the first century AD. The market still continues on Mondays, Thursdays, Fridays and Saturdays, while there are three other gems in this bustling former coal-mining town that are well worth visiting too.

Its best landmark is definitely the Church of St Mary and All Saints – known for its 'crooked spire', which was originally constructed in the fourteenth century. It is located at the top of the town centre and is free to enter. It's even possible to go up the spire itself for a small fee.

Above: Chesterfield Market is held on Mondays, Thursdays, Fridays and Saturdays. (Image courtesy of Chesterfield TIC)

Right: Revolution House. (Image courtesy of Chesterfield TIC)

The church itself is Grade I listed, with the north transept rebuilt in 1769 and restored in 1843 when a new ceiling and stained-glass window was added. Subsequent restorations occurred towards the end of the century. It's a beautiful place, but it's the spire that attracts attention. It was added to the fourteenth-century tower in around 1362 and is an oak frame, clad with lead. It reaches around 70 metres in height and leans close to 3 metres to the south-west.

It is thought the spiral was designed that way to set it apart from the rest, making it a landmark. It certainly wasn't designed to lean, however, and it was

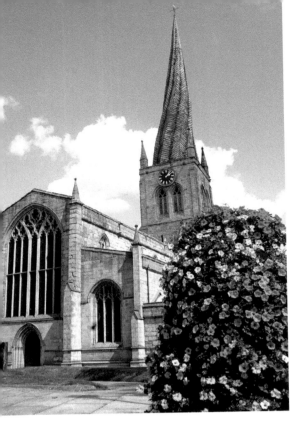

The unique 'Crooked Spire Church'.
(Image courtesy of Chesterfield TIC)

thought this occurred because of the use of unseasoned (green) timber, a lack of cross-bracing and the plague resulting in an absence of skilled workers. But it could also be because of the lead on the structure itself: the sun causing it to expand on one side rather than the other, causing it to buckle and twist.

At the southern side of the town centre is Queen's Park with its small lake. It's accessed from the town centre via a small footbridge and was opened in 1887 to celebrate Queen Victoria's Golden Jubilee. It has a café and miniature railway.

Another interesting place to visit is Revolution House, which is around ten minutes away from the town centre. This is where the Earl of Devonshire, the Earl of Danby and Mr John D'Arcy met at Whittington, disguised as a hunting party, to begin planning their part in the overthrow of James II in 1688.

On the day they met, a storm saw them seek shelter in the Cock and Pynot alehouse (now known as Revolution House) and the rest, as they say, is history. The House is a listed building now and at the time of writing was only open on Fridays and Saturdays until the end of September, but did open at Christmas.

Details

Chesterfield is off Junction 29 of the M1, via the A617. Revolution House is on High Street in Old Whittington, S41 9JZ.

Tower tours at the Church of St Mary and All Saints are daily during the main tourist seasons. They are priced at £6 for adults and £4 for children. Further details can be found at www.crookedspire.org.

42. Derby

Derby is a bustling city with origins stretching back to the Romans. They established the town of 'Derventio' before the Saxons and Vikings made it one of the five boroughs of Danelaw, the others being Leicester, Lincoln, Nottingham and Stamford. It then grew from a market town to be at the forefront of the Industrial Revolution. It was the site of the first water-powered silk mill (acclaimed to be the world's first factory) before cotton became the main production.

Nowadays, it is a busy place with plenty to see and do for the casual visitor and those wanting to spend a little longer. Gems are everywhere, so we present a few here that should whet your appetite.

Your first stop should be the Derby Museum and Art Gallery. It houses the world's largest collection of Joseph Wright paintings. He was an English landscape and portrait painter from the city and is credited as being the first to really capture the spirit of the industrial nature of Derby.

What is also fascinating about him is how his use of light depicts the Enlightenment – when art, philosophy, science and the Industrial Revolution were together as one, or at least those factions of society seemed more in tune with each other's thinking. His paintings show hope and excitement for the future. His landscapes, too, are stunning and display an intimate love of the area.

Next, make the short walk (around five minutes) to Pickford's House. This is a townhouse and garden, dating back to 1770, that was designed by Derby architect Joseph Pickford. It was his family home and a portfolio of what he could do. As well as celebrating the architect, the museum reflects on other passages of time and has a domestic scullery and kitchen set out as it might have been in 1830. There's also a basement air-raid shelter from the 1940s. It's an eclectic mix of displays, for sure, but it works.

Incidentally, the Silk Mill is being redeveloped at present and is expected to open as a museum in around summer 2020. It is also a UNESCO World Heritage Site and the new building aims to celebrate this.

Derby Cathedral should be next on your list. The original church was dedicated to All Saints and likely built in the tenth century. A new church was built four centuries later and the existing 65-metre tower was built over a twenty-year period from 1510. The tower survived another rebuild, with the first sermon held in 1725. It officially became a cathedral on 1 July 1927 and was extended eastwards by 1972.

Bess of Hardwick was buried at All Saints in 1608 and her striking monument survives today. It is also possible to climb the tower with advance tickets of £5 for adults and £4 for children being well worth it. Tickets include a free drink when purchasing a slice of cake or a scone in Derby Cathedral Bookshop. The majority of the bells are from around 1678; the largest dates back more than 500 years, making it older than the structure itself.

The cathedral is in the heart of the city and its cobbled quarter adds to the heritage. Nearby is Bennetts of Derby – the world's oldest department store, dating back to 1734. The Market Hall is Grade II-listed Victorian architecture and then you have the farmers' market, which is held on the third Thursday of every month.

Some other things to look out for are the Derby Book Festival week held during June and the Folk Festival in early October. There are also loads of great places to eat, and pubs too. The Dolphin Inn is Derby's oldest, dating back to 1530 and is pretty much as it would have been back then, while the Old Bell Hotel is 375 years old.

Details
Derby is off Junction 25 of the M1.

Derby Cathedral. (Image courtesy of Ashley Franklin)

South-West

43. Buxton

Buxton is one of my favourite places in the country, not only because of its natural beauty, but for the sheer variety of heritage and other attractions on offer.

It was originally settled by Romans, who called it Aquae Arnemetiae and built a bath at the site of a thermal spring. They understood its healing properties and considered it just as important as their other 'bath' site at Bath. But it wasn't until the 5th and 6th Dukes of Devonshire invested heavily in it that it became a real destination site, alongside the later advent of the railway.

The Devonshires had made their fortune from mining copper in the Manifold Valley and built the Crescent in Buxton to rival that of Bath's. John Carr was commissioned to undertake this task as he had already redesigned the decoration and furnishings of the private drawing rooms at Chatsworth, the Devonshires' other residence. Although they spent a lot of time in London, they would come north to Chatsworth and entertain their guests. Buxton was effectively gentrified by the building of the Crescent as a must-see tourist attraction for those wealthy people coming into Derbyshire. It had always been known for its spa waters – in medieval times people made pilgrimages to seek out its healing waters – but the dukes wanted it to make it a spa of national importance.

The now Grade I-listed Crescent, originally built between 1779 and 1789, was serviced by the Great Stables, which were also built by Carr. They were later converted into a charity hospital and then the Devonshire Dome was constructed – the largest unsupported dome in Europe. Originally, it provided accommodation for up to 120 horses and servants. Now it is part of the University of Derby's campus in Buxton and features a restaurant, beauty salons and a commercial spa. The Crescent itself is being redeveloped in a multimillion-pound project, with the focus returning to its natural baths and spa.

Opposite the Crescent is St Ann's Well, where you can enjoy the permanent flow of natural mineral water. Prior to the Reformation it was a pilgrim shrine

Buxton can be busy, so the lake at the Pavilion Gardens is perfect to relax by.

Inset: A yellow visitor. (Image courtesy of Millie Appleton)

and a small chapel stood there. It was dissolved on the orders of Henry VIII in 1538. The 5th Duke of Devonshire moved the well its current position and the existing structure was built around 1940.

Elsewhere is Buxton Opera House, which was designed by Frank Matcham in 1903. It is attached to the Pavilion Gardens, Octagonal Hall and the smaller Pavilion Arts Centre. The gardens, designed by Edward Milner, were opened in 1871 but it is thought that some of the earlier landscaping may have been designed by Joseph Paxton. Milner took on the task given to him by the Buxton Improvement Company and he laid out the 12 acres of land given to the town by the 7th Duke of Devonshire. He also constructed a winter garden and concert hall that echoed Paxton's Crystal Palace, built in London as part of the Great Exhibition of 1851. A recent lottery grant has allowed the gardens to be redeveloped once more and keep them more in line with Milner's original spec.

It's worth dropping into the fantastic Scrivener's, a gem of a book and bookbinding shop. The business was started by Alastair Scrivener in 1997 in a building that was originally a Victorian shop. The cellar still houses the old kitchen range and stone sink, which you can see when you're looking through the multitude of literature.

Details
Buxton is relatively simple to find, being off the A6 and A515 (Buxton Road).

44. Poole's Cavern

Poole's Cavern is a natural show cave in Buxton that is not only packed with vibrant and amazing formations but has an interesting history that stretches back to the 1400s.

Only a few steps from the entrance is the first chamber, a site of archaeological importance that gives some hint into who resided there in years gone past.

> This cavern is different to others in the Peak as it wasn't excavated by lead miners or people looking for Blue John. It isn't mineralised at all and there aren't any precious minerals on this side of the hill. The other side was quarried for limestone and there is plenty of evidence of that at Grinlow. It's all pretty natural apart from blasting early in the cavern and the creation of a footpath to the first chamber.
>
> When they came into the first chamber they found lots of prehistoric remains. Further excavations revealed items from across several periods in history and to be honest there's quite a confused picture in here. There was Roman jewellery too that wasn't buried as such; it seemed to have been thrown into the cavern. The Victorians thought it was a shrine or temple to commemorate a battle or event. There were burials that predated the Romans and it is possible that ancestors here at the time moved things around.

The guide says they also found crucibles and bits of jewellery that were bent and out of shape. It's possible that the people in this part of the cavern were scrap-metal dealers. They also found moulds for making simple little badges and bronze effigies of gods and plenty of coins.

The guide continued:

> This is said to the home of John or William Poole. Poole the Outlaw lived here in the 1400s and used it as a hideout. There's a lot of tales about who also lived here, including a nobleman who lost his wealth and some other vagabond who kidnapped wealthy ladies for ransom and buried treasure here.
>
> We have found silver coins from that period; they have been clipped around the edges which was a common practice of flashing. You'd melt down those clippings and make little silver objects to sell.
>
> There's probably some truth to the stories. Out of work soldiers were perhaps here during the Wars of the Roses and the Peak also has a number of stories about Robin Hood's hideouts. It's certainly a fascinating picture, and you're only in the first chamber.

Poole's Cavern is looked after by Buxton Civic Association, who helped reopen the site in 1977. It had been closed since 1965 upon the death of

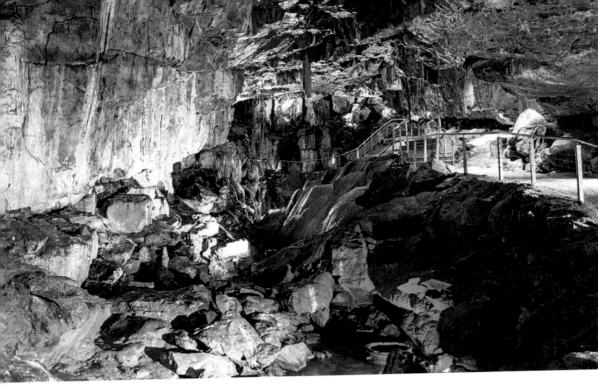

Poole's Cavern.

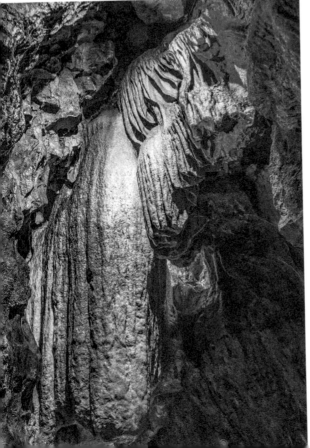

the last owner. The plan was to use the money generated by visitors to help manage the woodland on Grinlow above Poole's, which the association already looked after. It worked, too, as Poole's is very popular and the country park well conserved.

The cavern is officially around 800 feet long and although, technically speaking, we're not that deep underground it can take some six weeks for rainwater to filter through. The stream starts on Stanley Moor, some 0.75 miles away, which means there could be a significant cave system under the hill.

Eventually, we reach a large cavern, which I suspect is at least 100 feet high. It has a large stalactite hanging down called the Flitch of Bacon, which is the longest of any Derbyshire cave. 'It could be between 60,000 and 100,000 years old,' the guide points out. 'It has dried up now and isn't growing. Long time ago a visitor threw a rock at it and broke it. An early picture from the 1700s shows it had a broken end then so it must have happened before that. We found the broken piece in a neighbour's garden about ten years ago and we've put it on the floor just underneath it.'

Further on we come to the mind-blowing Poached Egg chamber. The formations here are breathtaking and are different to the ones early on. Some can take thousands of years to form, but it is thought that in this part of the show cave they grow 100 times faster.

Above the cavern the land was quarried for limestone and it was very pure. It was perfect for mortar use and for farmers to use on their land. Quarrying and burning created a lot of lime dust and once quarrying finished it settled on the hill. Once that is dissolved in rainwater and filtered through what is above us it appears to have made these stalactites grow quicker.

Some have grown a centimetre in a year and you'll see that they are orange on top too. We used to tell visitors that was iron, but geologists have taken samples and they can't find traces of that. Under florescent light, you can see the layers of each year's growth and can tell when there has been a wet summer or dry winter.

We think biological activity has caused that colour because of a reaction in the soil. When you work out how old these formations are then the theory fits with the quarrying above.

Towards the end of the cave you reach a long formation called the Mary Queen of Scots Pillar. She was interned in the late 1570s and would come to Buxton to bathe in local spas as she suffered from rheumatism. It is thought she visited Poole's Cavern and made it as far as this feature … although caving with rheumatism seems a little far-fetched.

This gave Poole's an air of wonder and a lot of people travelled to see where she had visited. Just a step back from the pillar is the name of Roland Lockey of London, etched into the stone. He was the official court portrait painter to

James I. In fact, there are lots of names here of visitors past and it's an incredible sight, a real piece of history depicting 400 years of this cavern's exploration.

The cave used to end here but the 'new ending' was opened in the Victorian era. Before then, guidebooks suggested you could pass into another chamber with some difficulty. And what a delight it is too, a fine sculpture chamber with stunning flowstone and cascades. The guide tells me there are possibilities for future discoveries too, but they are in the hands of cavers and diggers.

Back on the surface, the country park is well worth visiting. Grinlow shows how the lime-burning industry thrived in this part of the world and changed the landscape. It is a site of importance for nature conservation as unimproved upland limestone grassland and a habitat to rare plants such as orchids and alpines.

The wood itself was planted by the 6th Duke of Devonshire in the 1830s to hide the eyesore caused by quarrying. Remnants still remain, and there are plenty of interpretation boards to guide you on your journey to the top. He planted sycamore, beech, ash and elm as well as rowen, whitebeam, holly, lime and yew among other species. It is thought that 200 people lived on Grinlow when it was in its heyday and that a million tonnes of waste were deposited on it.

At the top lies Solomon's Temple, which is a Grade II-listed structure. It was built by public subscription to replace the original roughly built shelter. It is thought the duke paid for it to give work to unemployed lime workers he had ordered off the site. The duke had invested heavily in making sure Buxton was a trendy spa town to rival that of Bath and beyond. Lime dust gets everywhere and that wasn't good on the local population, nor the type of place he was trying to create. Therefore, he closed the quarry on the Buxton side of the hill to save the gentry from the pollution.

Details
Poole's Cavern is in Buxton and signposted. There is a small charge on the car park, while entry ranges from £9.75 for adults to £5.25 for juniors. There are also family prices too.

Solomon's Temple.

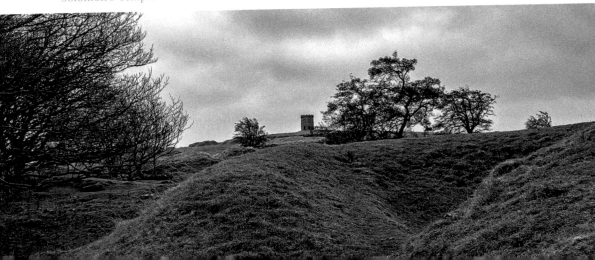

45. Chee Dale

The River Wye cuts a beautiful route through the Peak District and by the time it reaches Miller's Dale, near Blackwell, it has already passed through some stunning landscapes. But Chee Dale and Chee Tor in particular are real gems because of the variety you find on the approach.

Parking near the Monsal Trail after heading north on the B6049 through Blackwell Dale, you walk back down the hill and under the railway bridge to a gate on your right, which heads down to the river. Here, in an area overseen by the Derbyshire Wildlife Trust, the Wye has trees on either side, almost boxing it in and shielding you from everyday life. The colours are stunning whatever the season, with strong and vibrant greens reflected in the water surface. It's possible to see water voles here as well as plenty of bird life, and the river is so clean that fish pop up to the surface to bid you on your way.

After a while you emerge from the woodland into an open area, before heading into Chee Dale Nature Reserve. There are signs on the path warning you

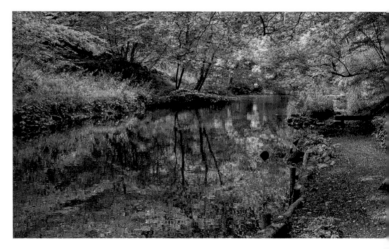

On the way to Chee Dale.

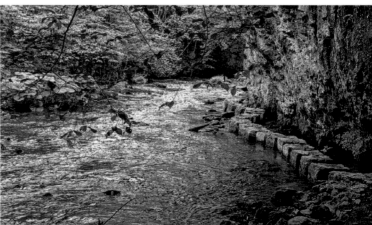

The stepping stones.

that it isn't passable in wet conditions and, as you'll find out, the path actually goes into the river via stepping stones further along the route. After following the Wye and enjoying the difference in landscape once again, you arrive at a stunning 200-foot-deep gorge that once again envelops you.

Climbers use the cliffs here to practise their skills, and around 50 metres further on the river bends right and you can pause underneath these limestone walls and take in the scene, with only the river and trees providing the acoustics.

Details

The best way to visit Chee Dale is to walk along the River Wye. Take the B6049 from the A6 and after around a mile or so there is a sharp turning on your left. From there, note the gate on the left-hand side as the road bends right (that's your walking route) and then go under the railway bridge. There is parking on your left (Monsal Trail) as the road steepens.

46. Three Shire Head

If you're looking for a serenely peaceful place to while away the hours in relative solitude, then Three Shire Head could be that gem. It is the point on Axe Edge Moor where Cheshire, Derbyshire and Staffordshire meet and the River Dane joins a tributary to make its way south.

Above each body of water are old packhorse bridges, indicating how important this spot was for traders from the nearby Flash village to Macclesfield

The meeting point of Derbyshire, Staffordshire and Cheshire. (Image courtesy of Richard Bowden via Shutterstock)

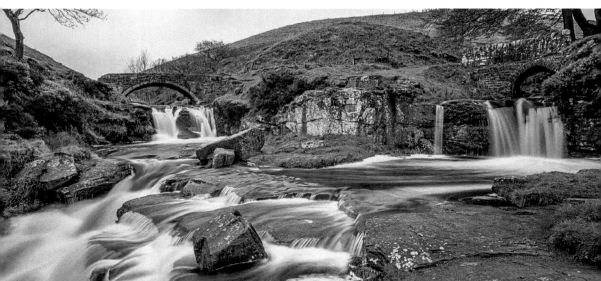

and beyond. It is thought that three or four packhorse routes interlock at this point. Next to the larger of the two bridges is Panniers Pool, where horses would have had a rest before their onward journey. That bridge, which the River Dane goes under, is listed and was likely constructed in the late eighteenth century.

It is also thought that this would have been an area where lawbreakers evaded capture by crossing into neighbouring counties. Police could only operate in their designated county and Flash, the highest village in England, had the reputation for illegal activities such as counterfeiting – commonly known as 'flashy' money!

Details
Three Shire Head is at around SK009685 and best approached on foot from Knotbury. Wild swimmers use the Panniers Pool and depending on the conditions it is around five to seven feet deep.

47. Lud's Church

This chasm above Gradbach is a curious spot, not only because of how it was formed, but because of the history and legend it holds.

The walk up to it isn't half bad either. Taking the route from Gradbach, you park in a small enclosure and then walk up the hill until you come to a gate on your right. You follow the signposted route down the road and then start to climb, before dropping onto a very muddy path. From there, you turn right and cross a tributary of the Dane on a footbridge. Climb up the hill and then turn a sharp left to reach Lud's Church in the Black Forest.

Once there, your first thought will be, 'Is that it?' But when you explore the chasm, you will find all manner of nooks and crannies and discover how big it is. It was formed by a landslip in millstone grit and is close to 350 feet long and in places some 60 feet deep. Above all, it's protective, which is important as it is thought to have hosted worshippers in the early fourteenth century.

The Lollards were followers of early church reformist John Wycliffe, and it is here they used to meet when they were being persecuted. The name could have come from a member who was captured there – Walter de Lud Auk – or the Celtic god Llud.

Standing in one of its chambers, you can see how nature has taken over the chasm. Mosses and plants grow all around and it's surprisingly cool. A walker I met at the same time said it was like that in summer too. It's a damp place as well. As you enter the chamber on the left of the entrance and climb down there is a boardwalk, but it was submerged in water and mud when I visited – take your boots.

There are legends, more likely myths, that say Robin Hood and even Bonny Prince Charlie hid here. You can imagine that too. Before the path, it would have

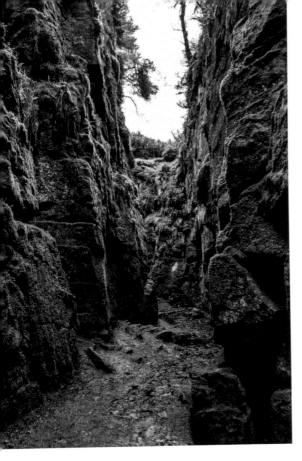

Lud's Church is an impressive sanctuary.

been an easy place to stow away, although where someone could hide inside with a search party at either end is beyond me. But I don't want to spoil a good story!

Details
Lud's Church is at SJ987656, while Gradbach is found by taking the route to Flash from the A53. Parts of this walk are very muddy, so it is advisable to wear good boots.

48. The Roaches

The Roaches are an impressive ridge not far from Upper Hulme on the A53. They are a famous rocky outcrop that steeply rises some 1,657 feet in places, making it very popular with climbers and walkers alike.

They are managed by the Staffordshire Wildlife Trust, stretch for a number of miles and at Hen Cloud in the south you have a solitary steep edge. Further up the ridge, the gradients are a little less severe, but still equally as impressive.

The Roaches is a busy spot, so the BMC help maintain the area with the aid of volunteers.

At the lower tier is the Rock Cottage, which is now a climbing hut after being a rather rudimentary gamekeeper's cottage. It's here that the attached photos of the BMC helping to manage the site were taken from.

It's also possible that you could see a wallaby too – yes, in Derbyshire. They were released during the Second World War from a private zoo at Swythamley and seemed to have survived until the late 1990s, when they disappeared; however, there still are sightings now and again, so you never know your luck.

At the top of the ridge, not far from the path, is Doxey Pool, a small pond that measures around 50 feet by 30 feet. Legend says that a mermaid lives in these bottomless waters, while another tale suggests that it was named after the

daughter of Bowyers of the Rocks – the legendary highwayman. Her name was Hannah, but she received the rather unflattering term of 'Doxey'.

Details

The Roaches are best visited from Upper Hulme, which is off the A53 road from Leek to Buxton. If heading north, take the left-hand turn after the Three Horseshoes Hotel. Go left once in the village and after around 1.5 miles there are lay-bys to park in. Doxey's Pool is at SK003628.

There is also a walk from Gradbach too, which is signposted when you reach the tributary to the Dane.

49. Chrome Hill

This magnificent peak is a gem simply because of how it looks from a distance and the nearby Parkhouse Hill. It's not called the Dragon's Back for nothing and is a stunning site when the sun rises.

It may only be at around 1,400 feet, but it has a dramatic feel with ridges, outcrops and other limestone features including Tor Rock and Dowel Cave. This is an old resurgence cave where excavations found the remains of ten Neolithic inhumations, while the hill itself features a number of fossils that realise its designation as a Site of Special Scientific Interest.

The view from Parkhouse Hill. (Image courtesy of Terry Abraham)

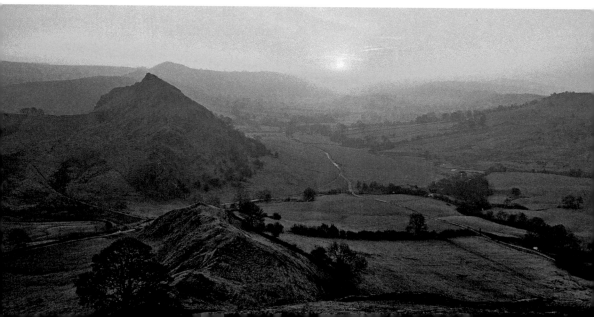

The best route to explore is probably from Crowdecote as you can visit the Packhorse Inn, a sixteenth-century pub that was a former stop-off point on the trail from Newcastle-under-Lyme to Hassop.

Details
The Packhorse Inn is at SK17 0DB off the A515 and Chrome Hill is at SK070673.

50. Thor's Cave

This cave is set high in a prominent crag south-west of Wetton in the Manifold Valley. It's around 150 feet long and looks almost impossible to visit from the valley floor. But there is a stepped path from the Manifold Way that makes life a lot easier – and the views are great.

Excavations have found several human and animal remains as well as tools and pottery in the cave. The nearby Fissure Cavern has yielded material that suggests it was occupied from the Palaeolithic period to Roman times.

Details
Thor's Cave can be visited from Wetton and is a SK098549.

Thor's Cave is in a steep limestone crag in the Manifold Valley. (Image courtesy of Angela, AEC Photography)

Inset: Excavations have found human remains; it is likely people lived and were buried here. (Image courtesy of Angela, AEC Photography)

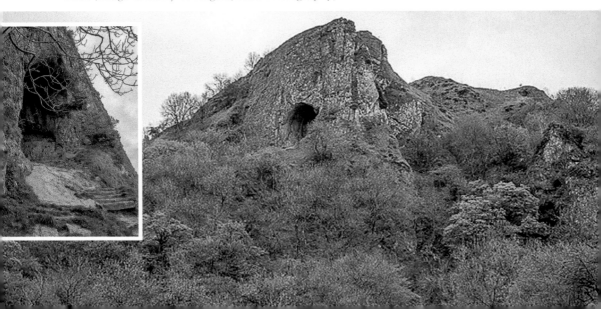

Acknowledgements

In putting this book together I'd like to thank, in no particular order, my eldest daughter Millie for helping me on my journeys (and taking two of the images herein), Bernard Platt for his superb picture editing skills, Alan Murphy and Becky Cousins at Amberley Publishing, Alison Riley at the Peak District National Park, Jody Vallance at the Moors for the Future project, Andrew White at Walks Around Britain, Tamaris Higham at the BMC, Mark Tierney and Chris Foster for their outstanding photos of Winnats Pass during the Waterlicht event, English Heritage, Hannah Marsden at the Chesterfield Visitor Information Centre, Michelle Booth from Derby City Council, Lady Edward at Haddon Hall, Alan Walker at Poole's Cavern, Sir Richard FitzHerbert at Tissington, Gary Ridley and Vicky Turner at Treak Cliff Cavern, filmmaker Terry Abraham, the couple I met at the top of Grindsbrook who encouraged me to climb down, the well dressers of Eyam that took time out to demonstrate their art, and Angela Clarke for her help with Thor's Cave.

Special thanks should also go to Phil Wolstenholme, who was nothing but stellar in helping me pen my entry on Peak Cavern. Phil was only too pleased to help when we were introduced on the ukcaving.com forums and what ensued was a fact-filled meeting at the Technical Speleological Group's 'Chapel' in Castleton before a detailed trip through Peak Cavern. The experience is one I will savour for the rest of my life and it is solely down to Phil that this happened. I'd also like to thank Ann Soulsby and Alan Brentnall for accompanying us on the trip too. Without their help, the Peak Cavern section of this book would be a shadow of what it is now. With that in mind it is only fair to pay recognition to John Harrison too. He is the director of Speedwell and looks after Peak, and if he had barred access to the cavern then that would have been that!